A–Z

OF

STRATFORD-UPON-AVON

Places - People - History

Will Adams

AMBERLEY

First published 2018

Amberley Publishing
The Hill, Stroud, Gloucestershire, GL5 4EP
www.amberley-books.com

Copyright © Will Adams, 2018

The right of Will Adams to be identified as
the Author of this work has been asserted in
accordance with the Copyrights, Designs and
Patents Act 1988.

ISBN 978 1 4456 8479 6 (print)
ISBN 978 1 4456 8480 2 (ebook)

British Library Cataloguing in Publication Data.
A catalogue record for this book is available
from the British Library.

Origination by Amberley Publishing.
Printed in Great Britain.

Contents

Introduction 4

Alveston Village and
 Manor 6
Mary Arden 8
River Avon 9
Avonbank and
 Mrs Gaskell 11

The Bancroft Gardens 12
Sir Frank Benson and
 the 'Bensonians' 13
The Birthplace and the
 Birthplace Trust 14
William Bridges-
 Adams 16

Chain Ferry 17
Hugh Clopton and
 Clopton Bridge 18
Marie Corelli 19
Cox's Yard and the
 Attic Theatre 21

The 'Dirty Duck' and
 Dame Judi Dench 23

Elizabeth House 25
Evesham Road
 Cemetery 26

The Flower Family and
 Flowers Brewery 28
Levi Fox 30

David Garrick and the
 Garrick Inn 31
Gower Memorial,
 Bancroft Gardens 33
Guild Chapel 34

Dr John Hall and Hall's
 Croft 36
Sir Peter Hall 37

Harvard House 38
Anne Hathaway 40
Holy Cross
 Almshouses 41
Holy Trinity Church 42

Sir Henry Irving 45

The Jester 47
The Jubilee of 1769 48

K6 Telephone Kiosk 49
King Edward VI
 School and Former
 Guildhall 50

The Library 52

Mason Croft 54
Mop Fair 56

Nash's House and
 New Place 57

The Old Bank,
 Chapel Street 59
The Other Place 60
Other Stratfords! 61

John Payton, the
 White Lion and
 New Town 63
John Profumo 64

Anthony Quayle 65
Thomas and Judith
 Quiney, née
 Shakespeare 66

The Racecourse 68
Railways 68
Rother Market and the
 'American Fountain' 71
Royal Label Factory 72

Royal Shakespeare
 Theatre 74

William Shakespeare 77
Shrieve's House, Sheep
 Street 78
'Stratford Blue' 79
Stratford-upon-Avon
 Canal and Basin 81

Town Hall 83
The Tramway Bridge and
 Tramway House 84

Union Street 87

Victoria Spa,
 Bishopton 88

The Welcombe Hotel 90

Xmas All Year Round! 92

F. R. S. Yorke 93

'Zed! Thou unnecessary
 letter!' 95

Acknowledgements 96
About the Author 96

Introduction

It is very difficult to visit, walk around and appreciate the town of Stratford-upon-Avon without tripping over William Shakespeare at almost every turn. If ever a town was given over to the celebration of its one famous historical claim to fame, it is Stratford – 'The Immortal Shrine' according to the title of a town council guidebook published in the 1930s. Yet it was not always so. 'Bardolatry' – Shakespeare worship – only took root in the latter half of the eighteenth century, more than 150 years after the playwright's death at New Place. Pre-Shakespeare Stratford was just another bustling Midlands town, with no predominant industry but well placed at a crossing of the Avon to serve as a market and focus of agricultural activity over a wide area. At first the settlement was near where Holy Trinity Church stands, then in the late twelfth century a 'new town' was planned a little further north on the grid street pattern that is still evident today. Sadly the Tudor town of the sixteenth and early seventeenth centuries was ravaged by fire four times, after which building with brick was encouraged. In the early nineteenth century expansion brought elegant Regency and Georgian buildings, and a new 'New Town' beyond Bridge Street. In the nineteenth century the canal, then the railway, brought further prosperity, as they did to countless towns throughout the country. Nor should we forget the town's striking modern buildings, not least the Royal Shakespeare Theatre of the 1930s, further altered and modernised in recent years.

Meanwhile the enigmatic presence of William Shakespeare flitted in and out of the town for just a few decades between 1564 and 1616. He may have been born in the Birthplace in Henley Street, he possibly attended the Grammar School, he certainly lived at New Place, which is no more, and was buried – under an enigmatic epitaph – in Holy Trinity Church. He married Anne Hathaway, whose family's 'cottage' is now the quintessential 'chocolate box' archetype, and his mother turned out not to have lived in 'Mary Arden's House'. He had children and grandchildren, but there the direct family line ended. Yet I am sure that it is what we *don't* know about Shakespeare that draws 2½ to 3 million visitors to the town annually, hoping somehow to pin down this elusive genius, and to capture something of his essence from these scraps of information and fragments of timber, bricks and mortar.

Sadly there are some aspects of the whole Stratford 'experience' where the veneration of Shakespeare seems to have led to the 'stuffing and mounting' of the town's heritage. Although still within the same timber frame, the Birthplace is very much restored and no doubt looks nothing like the house that Shakespeare would have known, nor would he recognise Henley Street, with its cafés and shops stacked with gifts and souvenirs. A million photographs and selfies will do nothing to conjure up a sense of the real man in the real muddy and smelly world of sixteenth-century Stratford.

Yet as I researched this book I found that without the influence and intervention of just a few key people, the whole Shakespeare thing may never have flourished as it did. It was the eminent actor David Garrick who organised the first real Shakespeare festival in 1769 (although none of the plays were performed), the Flower brewing family who helped to finance the practical development of interest in the Bard, and interfering eccentric novelist Marie Corelli who succeeded in making many enemies in the town but also by her persistence ensured the survival of some of the most important bits of Shakespeariana that we enjoy today. Other important people are also featured herein, from Hugh Clopton, who bridged the Avon and whose late fifteenth-century generosity helped to shape the town, to Dr Levi Fox, the celebrated director of the Shakespeare Birthplace Trust, not to mention the many actors, producers and directors who have steered the Royal Shakespeare Company and its theatre to international pre-eminence. The town's name itself has also spread around the world, and some other Stratfords, named in honour of the Warwickshire original and often with suitable Shakespearean street names, are mentioned here.

So while the spirit of Shakespeare runs like the Avon through the following pages, there is much more to enjoy and appreciate in Stratford-upon-Avon if you chip away at the encrustation of bardolatry and see the town for itself, with its wonderfully varied architecture, its delightful open spaces and riverside, and its industrial and civic history. Put down the camera for a moment, look above street level and behind the tourist honeypot shopfronts, and, as the great architectural historian Nikolaus Pevsner wrote, 'make the gigantic effort of forgetting Shakespeare and the pilgrims and the trippers ... Once Shakespeare is out of the way and once you can see Stratford out of season, you can still visualise the thriving market town with the comfortable, staid, minor Georgian town superimposed on it.'

This book is not a comprehensive history of or descriptive guidebook to Stratford, but I hope that the almost sixty entries will provide an instructive and entertaining sketch of the town and its history and encourage the reader to find out more – all the places herein are available to the public either as visitor or guest.

Alveston Village and Manor

Alveston village lies east of Stratford on the River Avon and has been part of the borough since 1924. The land was held by Worcester Cathedral from at least the tenth century until the sixteenth when, at the Dissolution of the Monasteries, it passed to the Crown.

The present-day church is nineteenth century, but in the old abandoned, partly demolished and restored church one of the oldest and most interesting monuments is that of Nicholas Lane, who died in 1595 and was a contemporary and adversary of William Shakespeare's father, John, to whom he may have lent money.

A statue of William Shakespeare adorns the gardens in front of the Alveston Manor Hotel.

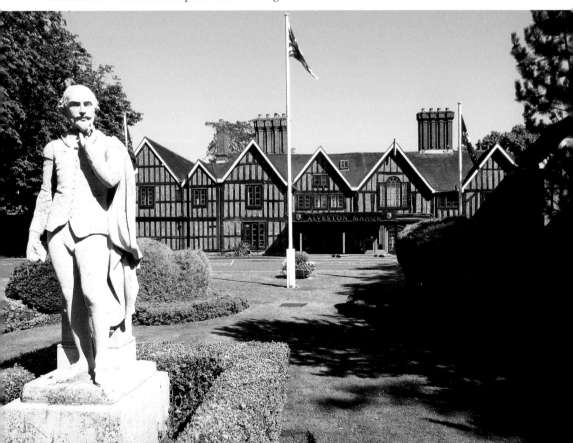

The Manor House, nearer Stratford at Bridgetown on the south bank of the river, is said to occupy the site of an anchorite cell from around AD 960. The house we see today is mostly timber framed with brick infill, many panels having decorative brick and tile work. It dates from at least 1500, and was enlarged in around 1600 with further alterations and renovations taking place in the eighteenth and nineteenth centuries. In its present role as a hotel there are also twentieth-century additions. In around 1570 the Manor House was sold for £576 9s 2d; it subsequently passed through many hands, and in 1810 it was sold for £39,500.

The Alveston village website considers it likely that Shakespeare would have known or passed through the village – his father had land across the Avon on the Welcombe Hills, and the river here was easily fordable. It is thought that the old church may have inspired the graveyard scene in *Hamlet*. Also, in 1579, when the future playwright was fifteen years old, a young woman was found drowned in the Avon at Alveston. Her name was Catherine Hamnet – a name not dissimilar from Hamlet – and it is thought that the story may have inspired the drowning of Ophelia. Also, only a couple of miles further east up the river is Charlecote Park, where Shakespeare is traditionally supposed to have got into trouble for poaching deer.

Another Shakespeare connection is that under the huge cedar tree at the rear of Alveston Manor the first performance of *A Midsummer Night's Dream* is reputed to have taken place. This so-called 'kissing tree' is also said to be where young William enjoyed his first kiss!

The Bird family bought the manor in the 1930s and were the first to turn it into a hotel. During the Second World War the Canadian Army and Air Force had connections with it, then after the war it reverted to a hotel. Today, as the Macdonald Alveston Manor Hotel, it is one of the finest four-star hotels in the county.

The Manor was listed Grade II in 1951.

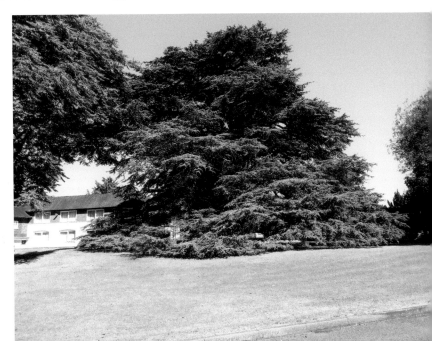

Is this the tree under which tradition has it the first performance of *A Midsummer Night's Dream* was performed?

Mary Arden

As with her famous son William, relatively little is known about Mary Shakespeare, née Arden. She was born in around 1537, the daughter of Robert Arden, of an old and distinguished Warwickshire family. The youngest of eight daughters of Robert and his second wife, Agnes Hill, she was born and raised on the family farm in the village of Wilmcote, 3½ miles from Stratford, and inherited some money and land when her widowed father died at the end of 1556.

Mary was from a high-status family, so her marriage at nearby Aston Cantlow to John Shakespeare, the son of one her father's tenant farmers, a mere yeoman, may have raised a few eyebrows. She was certainly a good catch for John. They married in 1557, shortly after Mary's father's death, when she was twenty and John twenty-six – it is possible that Robert would not have approved of such a liaison. She bore John eight children, and five of them, including of course her first son, William, lived long enough to see the new century; indeed, Joan, William's younger sister, did not die until 1646, aged seventy-seven, thirty years after the death of her famous brother.

The family farm survived through the centuries in good condition, and in 1930 was bought and suitably refurnished by the Shakespeare Birthplace Trust. In 1968 the trust also acquired the neighbouring 'Palmer's Farm', to help preserve the integrity of the location. Then, in a strange twist of fate, it was recently discovered that the building known for many years as Mary Arden's House, visited by thousands of Shakespeare

This beautiful and 'delightfully irregular' (Pevsner) building has always been known as 'Mary Arden's House', but it has recently been discovered that it was in fact occupied by farmer Adam Palmer. The farmyard, now a popular visitor attraction, can be glimpsed beyond.

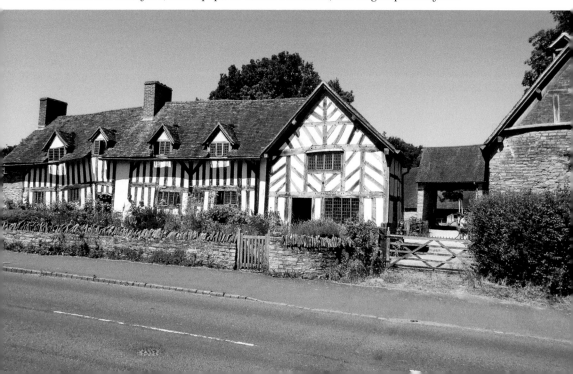

This, it turns out, is actually where the Ardens lived, next door at Glebe Farm, a much plainer brick and stone building. Happily both had been purchased and cared for by the Shakespeare Birthplace Trust.

devotees, was not in fact her birthplace, but had belonged to friend and neighbour Adam Palmer, and that the adjoining Glebe Farm had been the Arden residence. The house and farm are now open as a tourist attraction, authentically recreating the sights, sounds (and smells!) of sixteenth-century agricultural life.

It appears that Mary could not write – she is known to have signed legal documents with a mark (as did John) – but she may have been able to read. How she reacted to her husband's fall from grace in the Stratford community we do not know. In fact, this is pretty much all that is known of Shakespeare's mother. The date that she died is unknown, but her funeral took place in September 1608. She did not leave a will, and there is no known portrait of her.

River Avon

The Avon is central to the iconography of William Shakespeare – it was in the 1880s that he was first dubbed the 'Bard of Avon', while only a few years after his death, in a memorial poem, Ben Jonson referred to Shakespeare as 'Sweet Swan of Avon' (there was an ancient Greek belief that the souls of poets passed into swans). This association makes the Warwickshire Avon perhaps the best known of the eight English

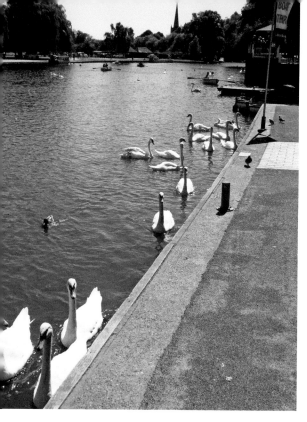

'Swans of Avon': the river and its swans and other waterfowl are central to Stratford and the iconography of Shakespeare.

and Scottish Avons (the well-known Bristol Avon, one in Devon, a couple in Hampshire and three in Scotland). Why so popular a name? Simply because the name derives from the Old British word 'abona', meaning river (the equivalent of 'afon' in Welsh and 'abhann' in Irish). So the Avon is really the River River! Incidentally, 'Stratford' itself is a common English place name, and indicates a location where a Roman road (the 'Straet' part of the name) forded a river – all the Stratfords are on Roman roads.

The Shakespeare Avon, as it is sometimes dubbed, rises near Naseby in Northamptonshire, where it forms part of the border between that county and Warwickshire. It then flows generally south-westwards for 85 miles, passing through Rugby, Warwick, Stratford and Evesham (the Upper Avon), and thence to join the River Severn at Tewkesbury (the Lower Avon). To reinforce the Shakespeare connection there is a well-marked 88-mile-long footpath following the river from its source to the Severn, marketed as Shakespeare's Avon Way.

Work to make the river navigable was first authorised by King Charles I in 1635, and today it is navigable from Alveston weir, upstream of Stratford-upon-Avon, as far as the Severn. In 1816 the river was connected to the Stratford-upon-Avon Canal (qv).

In 1949 restoration of the Lower Avon to navigable condition was put in hand, then in 1965 the Upper Avon Navigation Trust Ltd was constituted to restore the Upper Avon. The 17-mile navigation, which had been derelict for more than 100 years, was completed in 1974, the largest project of its type to that date. Subsequently there have been proposals to extend the navigation upstream from Alveston to link with the Grand Union Canal at either Warwick or Leamington Spa, previously not navigable.

Today the river around Stratford is used exclusively for leisure purposes, and several companies offer visitors boat rides, enabling them to see the town from a different angle, and float among the present-day 'swans of Avon'.

Avonbank and Mrs Gaskell

A Miss Byerley (a niece of Josiah Wedgwood, the famous potter) opened a boarding school in Warwick in 1810; it moved to Barford in 1817, and to a large eighteenth-century house known as Avonbank in Stratford in the early 1820s. At this time one of the pupils was Elizabeth Stevenson. Born in Knutsford, Cheshire, and brought up by an aunt, Elizabeth was sent to the school at the age of eleven, and in adult life became famous as the novelist Mrs Gaskell. The house was next to Holy Trinity Church and had been built on the ruins of an old priory, with lawns sloping down to the river.

The curriculum no doubt included the essential accomplishments for young ladies of that era, such as dancing, music, drawing, English, languages and arithmetic. Young Elizabeth also saw what she could of Warwickshire; she recalls a school trip to Clopton Hall, 'a large, heavy, compact, square brick building, of that deep, dead red almost approaching to purple'.

Elizabeth left Avonbank in 1826 at the age of sixteen, and the Byerleys left in 1840, leasing the house to the Misses Ainsworth, who ran the school until 1859. Avonbank was then auctioned on 20 August 1860 and bought by brewer Charles Edward Flower (qv) for 2,000 guineas. It was let as a school for a few years before being vacated and demolished in 1866. The following year Charles Flower commissioned an architect to design a 'very modern villa'. That house was itself demolished in the mid-1950s, and the only part to survive today is the Orangery, while the gardens have become a public open space.

All that remains of Charles Flower's Avonbank House is this Orangery. Avonbank Garden is a public open space that belongs to the theatre, and the building is adorned with large colourful panels depicting RSC productions.

The Bancroft Gardens

The Bancroft (a 'bank croft', or riverside meadow) was originally an area of land where Stratford townsfolk grazed their animals. In 1816 it was where the canal basin for the Stratford-upon-Avon Canal was established, where it met the Avon. Here there were canal wharfs and warehouses, and a second canal basin was built in 1826, although this was infilled in 1902 with the development of the gardens.

In 1874, 2 acres at the south end of the site were donated by Charles Flower (qv) for the erection of the first Shakespeare Memorial Theatre, which opened in 1879. The Bancroft was subsequently developed as a public open space, its riverside setting making it one of the town's most visited landmarks, with more than a million visitors each year. It has a tree-lined walk, lawns and flower beds, together with the surviving canal basin, now a marina.

The gardens also include the well-known Gower Memorial (qv) of 1888. A more recent addition is the Country Artists Fountain, or Swan Water Fountain, installed to mark the 800th anniversary of the granting of the Market Charter by King Richard I in 1196. Representing two rising swans and constructed of stainless steel and brass, it is the work of Christine Lee and was unveiled by the Queen in 1996. There is also a human

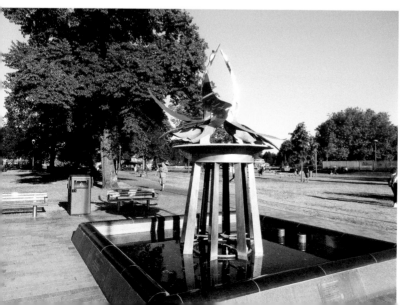

Christine Lee's Country Artists Fountain, or Swan Water Fountain, consisting of rising swans in stainless steel, is one of several sculptures in Bancroft Gardens. It was unveiled by the Queen in 1996.

sundial of 2008–09, celebrating the Warwickshire Fire and Rescue Service, a new performance area and two fully accessible bridges over the canal basin and the lock.

In recent years the gardens were extensively redeveloped in connection with the remodelling of the Royal Shakespeare Theatre. Costing £3 million, there were new flower beds, and a new bridge and viewing platform over the canal lock. Shakespearean actor Sir Donald Sinden reopened the gardens on Shakespeare's birthday, 23 April 2009. The riverside walk alongside the theatre has also been reopened and it is now possible to walk from the gardens, beside the theatre, to Holy Trinity Church.

Sir Frank Benson and the 'Bensonians'

Francis Benson was born in Hampshire in 1858. After leaving Oxford University he became a professional actor, and made his first stage appearance in London under Henry Irving in 1882. The following year he formed his own company, and in 1901 established an influential acting school. His stated aim was to 'train a company, every member of which would be an essential part of one homogenous whole, consecrated to the practice of the dramatic arts and especially to the representation of the plays of Shakespeare'.

Strangely, many of Shakespeare's plays had not been produced for many decades, but from the outset Benson devoted himself to their revival; subsequently his companies performed all but three of them. They performed in Canada in 1913 and in South Africa in 1921, and Benson is especially remembered for his portrayals of Hamlet, Coriolanus, Richard II and Petruchio in *The Taming of the Shrew*. In 1886 he married, and his wife joined the company and played many leading parts with her husband. Most notably from Stratford's point of view, he was appointed to run the Memorial Theatre's Shakespearean Festivals, producing twenty-six between 1886 and 1916.

Benson was a striking actor both physically and in his delivery (he was a cousin of actor Basil Rathbone, to whom he bore a strong resemblance). In 1916, the 300th anniversary of Shakespeare's death, he was knighted by King George V in the Royal Box at Drury Lane Theatre following a performance of *Julius Caesar*. As well as his stage performances, he also played in four silent film versions of Shakespeare plays in 1911.

The Memorial Theatre contains a portrait and a bronze head of Benson, and on the first floor of the original theatre there is a magnificent stained-glass window commemorating the Benson Company. Many former 'Bensonians' are portrayed; there was also Shakespeare's coat of arms and the famous phrase from *Henry V*, 'We few, we happy few, we band of brothers'. In 1932, when the new theatre was opened, twelve new portraits were added, dedicated by Sir Frank Benson himself.

Benson died on the last day of 1939, and in 1950 the coat of arms and quotation were moved and replaced by a portrayal of Benson as Richard II. Much respected in Stratford, he was credited with restoring the works of Shakespeare to the stage, rescuing late Victorian theatre from the control of the actor-managers of the time, and restoring the tradition of British acting.

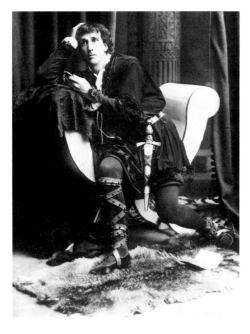

Frank Benson as Hamlet. One can see the physical resemblance between him and his cousin Basil Rathbone. (Commercial postcard, author's collection, *c.* 1907)

The Birthplace and the Birthplace Trust

The building known as Shakespeare's Birthplace, the largest house in Henley Street, is where William was most probably born and certainly grew up; he also spent the first five years of his married life here. The house was originally in two parts, from one of which William's father, John, carried on his business as a glove-maker. In 1568 John was Mayor of Stratford, and until later financial problems beset him he was a wealthy and influential figure in the town.

The house is a typical half-timbered mid-sixteenth-century building, originally with a simple rectangular plan. There were three principal rooms on each floor; that above the parlour is traditionally thought to have been where William was born. A separate smaller house was later built on, and the present kitchen was added at the rear, with a room above.

The Shakespeares were certainly in residence by the mid-1550s, and the building was inherited by William on his father's death in 1601. He himself was living at New Place by then, so the house was leased out and converted into an inn, the Maidenhead (later the Swan and Maidenhead). When William died in 1616 the smaller house was occupied by Joan Hart, his recently widowed sister, and the whole property passed to Susanna Hall, William's eldest daughter.

In 1649 it passed to Susanna's only child, Elizabeth; she had no children, so in 1670 it passed to Thomas Hart, a descendent of Joan, and the Harts continued as tenants of the smaller house after Joan's death in 1646. The whole property remained in the Hart family until 1806, when it was sold to a butcher, who continued to run the inn.

When the Shakespeare family links with the house came to an end, it fell into disrepair until interest in the playwright increased from the eighteenth century. It then began to be visited by admirers (including Dickens and Sir Walter Scott), some of whom autographed the windows and walls, the latter signatures long since painted over.

The inn was put up for sale in 1846, and the American showman P. T. Barnum expressed an interest in shipping it to the States brick by brick. Happily, the Shakespeare Birthday Committee (which became the Shakespeare Birthplace Trust in 1891) raised the necessary £3,000 and bought it the following year as a national memorial. Restoration began, and adjoining properties were removed as a fire precaution.

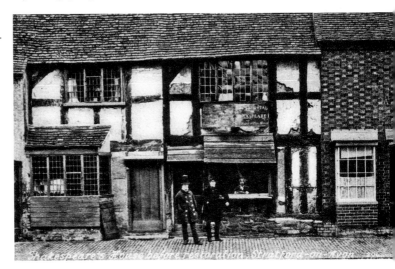

Right: 'Shakespeare's House before restoration' – there is a worn sign indicating the building's fame, but otherwise it is in poor repair. (Commercial postcard, author's collection)

Below: The Birthplace today, heavily restored in 1858 to what it looked like in a drawing of 1769. It is difficult to relate the two photographs. The 1960s Shakespeare Centre can be seen beyond.

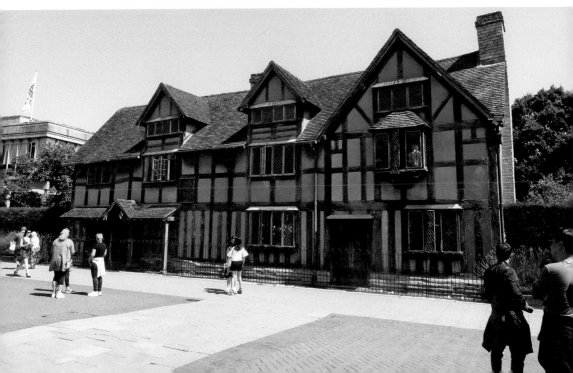

Between 1857 and 1864 the trust restored the outside to its original condition as portrayed in an eighteenth-century drawing, and the property now recreates a family home of the period, with appropriate domestic furnishings, as well as John's glove-making workshop. The garden behind has been specially planted with flowers and herbs that would have been familiar in Shakespeare's day.

The headquarters of the trust, the Shakespeare Centre, a modern glass, concrete and brick building opened in 1964, now adjoins the Birthplace. The trust cares for the five internationally famous properties associated with the playwright and also holds the world's largest Shakespeare-related library, museum and archives, which are available to the public and have been designated of international importance. The collection includes more than a million documents, 55,000 books and 12,000 museum objects, as well as the Royal Shakespeare Company's archives and general local history records dating back to the twelfth century. The collection includes the First Folio of Shakespeare's works, as well as a signet ring believed to have belonged to him. The trust is also the headquarters of the International Shakespeare Association and plays an active role in the World Shakespeare Congress.

William Bridges-Adams

William Bridges-Adams (1889–1965) – not to be confused with his grandfather, the author and railway inventor of the same name – succeeded Sir Frank Benson (qv) as director of the Shakespeare Festival at Stratford in 1919. After graduating from Oxford, Bridges-Adams occasionally worked as an actor, but more often as a director and a designer, starting in 1912. As director of the Shakespeare Festival, he was determined to lift the theatre from the national mood of post-First World War gloom, and approached the project with great enthusiasm. Between 1919 and his retirement in 1934 he produced twenty-nine of Shakespeare's plays, with the text uncut – this was unusual, and earned him the nickname 'Mr Unabridges-Adams'.

In 1926 the original Memorial Theatre at Stratford suffered a disastrous fire, and Bridges-Adams moved the company to a cinema owned by the Flower family, where five festivals were staged. His design for the stage of the new theatre was adopted by its architect, Elisabeth Scott, and together they spent a year developing detailed plans and visiting theatres in other countries. He said that 'the need is for absolute flexibility, it should be, so to speak, a box of tricks out of which the childlike mind of the producer may create what shape it pleases'.

The Dictionary of National Biography claims that Bridges-Adams was frustrated by the failure of the theatre's governors to support his attempts to gain an international status for the theatre. Nonetheless, his distinguished career continued through and beyond the Second World War in a variety of eminent artistic posts. He died at his home in Ireland in 1965, at the age of seventy-six.

C

Chain Ferry

A novel and attractive way to cross the Avon is by the town's chain ferry, which links Waterside, between the Royal Shakespeare Theatre and Holy Trinity Church, with the water meadows on the opposite bank. It opened in 1937, and was the last of its kind to be built in Britain (there are a dozen or so surviving chain or cable ferries up and down the country, fewer than half of which are strictly chain ferries). The initial idea was for a bridge, but this was not popular and would not be ready in time for that year's coronation of King George VI. A similar chain ferry existed in Cambridge, so that model was chosen instead. It was built locally and on 10 May 1937, two days before the coronation, the town's mayor piloted it across the river on its maiden voyage.

By 2006 the ferry was carrying 100,000 people annually, and it was again suggested that it be replaced by a bridge. However, the vessel (named *Malvolio*, after the

The Chain Ferry makes its leisurely way towards the south bank of the Avon, wound across by hand. The fare in 2018 was 50p.

character in Shakespeare's *Twelfth Night*) was overhauled and refurbished in 2010 by local firm Avon Boating Ltd, and resumed service. The timberwork was replaced using the original plans, but all the original metal was retained. Avon Boating now runs the ferry under licence from Stratford District Council, and it operates daily from mid-March to the end of October.

The journey takes just a couple of minutes – much quicker than using one of the bridges – and costs 50p (2018).

Hugh Clopton and Clopton Bridge

Hugh Clopton was born in around 1440 at the family seat of Clopton House, near Stratford. He left for London at an early age and became a mercer. By 1485 he was an Alderman in the City, the following year he was elected Sheriff of London, and became Lord Mayor in 1491. His great wealth now enabled him to purchase the ancestral estates at Clopton, and he also built what became known as New Place in Chapel Street, which would later be the home of William Shakespeare.

Clopton made repairs and improvements to several of the town's buildings, and was also responsible for the construction of Clopton Bridge across the Avon in around 1484. His new stone bridge had fourteen arches, with a long causeway at the western end, and was built over the remains of the original Roman ford. It made a huge difference to Stratford's fortunes, as previously there had only been a wooden bridge dating back to 1318, which was impassable when the Avon was in flood. The historian John Leland described the new structure as a 'great and sumptuous Bridge', its predecessor having been 'a poor bridge of timber and no causey [causeway] to it, whereby many poor folks and other refused to come to Stratford when Avon was up, or coming thither stood in jeopardy of life'. Now they could travel safely to the markets, and the town began to thrive.

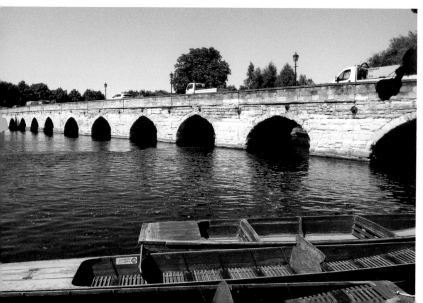

Most of the fourteen arches of Clopton Bridge can be seen in this view from the eastern bank of the Avon. Although well over 500 years old, it still carries heavy traffic in and out of the town.

The 1814 crenellated toll house at the town end of the bridge has recently been restored and refurbished to provide office space.

Various repairs were carried out over the years, including the rebuilding of an arch that was destroyed in 1645 to halt Cromwell's army. In 1696 the parapets were raised, being as low as 4 inches in places. The bridge was widened and a toll house added in 1814, and an adjoining cantilevered cast-iron footbridge was added in 1827. The toll house has a crenellated roofline and Gothic windows and after falling into disrepair has recently been restored and refurbished to provide office space. The bridge and toll house are Grade I listed as 'An important survival of a medieval bridge forming a significant landscape feature'.

Hugh Clopton died in London in 1497, and was buried there, although he had wanted to be interred in his beloved Stratford. His will provided for the completion of his improvements in the town, as well as other generous bequests to benefit the townsfolk. Clopton House, where it is said that Sir Hugh entertained David Garrick and others beneath a mulberry tree in 1742, is now divided into apartments.

Marie Corelli

Born Mary Mackay in 1855, she began her career as a musician under the name Marie Corelli. Later she became a novelist of romantic fiction, and her somewhat melodramatic books were enormously popular, although they did not always meet with critical acclaim. *The Spectator* described her as 'a woman of deplorable talent who imagined that she was a genius, and was accepted as a genius by a public to whose commonplace sentimentalities and prejudices she gave a glamorous setting'.

For more than forty years Corelli lived with her companion, Bertha Vyver, although the exact nature of their relationship is unclear. In 1890 they spent ten days in Stratford, staying at the Falcon Hotel. They signed the visitors' book at Shakespeare's Birthplace, went boating on the river, and visited the Flowers' home beside the Avon. In 1897 Marie fell ill and had an operation; her doctor recommended at least two years' convalescence in the country. Bertha suggested Stratford, and in 1899 they took

a lease on Hall's Croft (qv), then privately owned. Marie was welcomed as the most successful living author and typically threw herself into the social life of the town, as guest of honour at public functions, opening bazaars and making speeches. The local paper reported that, 'During the comparatively brief time she has been among us, Miss Corelli has identified herself with everything that tends to make the social life of the town bright and pleasant, and she has also shown unstinted generosity in her contributions to our charitable institutions.' Her home became almost more famous than that of the town's celebrated literary son.

In 1900 Marie and Bertha took a lease on the fine eighteenth-century house known as Mason Croft (qv) in Church Street, and made it their home. Now a Stratford fixture, Marie campaigned vigorously for the preservation of the town's historic buildings. However, she gained a reputation as a meddler, and became well known for her eccentricity – she could be seen on the Avon in a gondola, complete with gondolier, which she brought from Venice in 1904. Lost for many years, the gondola is now owned by Nick Birch of Avon Boating. In 1902 two Shetland ponies, named Puck and Ariel, arrived, and pulled Marie and Bertha's small chaise around the town.

In 1903 Marie became embroiled in a controversy about the siting of a new Carnegie public library (qv) near Shakespeare's Birthplace, saving the five cottages that were due to be demolished. It developed into a libel case, which went to court – she won, but was awarded only a farthing damages, and made many enemies in the town.

When she died in 1924 Marie left everything to Bertha. She was buried in Evesham Road cemetery (qv), later to be joined there by her companion. Her memorial was

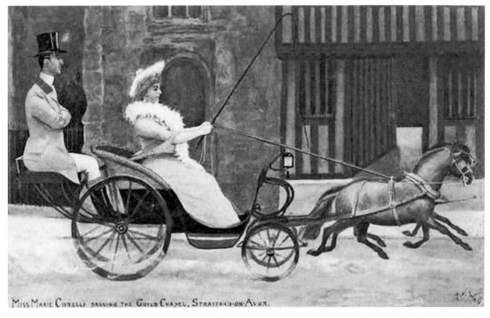

Marie Corelli, eccentric celebrity and ardent preservationist, passes the Guild Chapel in her chaise pulled by Shetlands Puck and Ariel. (Commercial postcard)

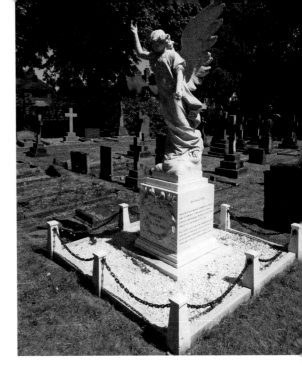

Marie Corelli's restored grave in Evesham Road Cemetery. She died in 1924, and her companion Bertha Vyver joined her here in 1941.

later vandalised, but Nick Birch led a project to have it fully restored and replaced in its original location, and it was unveiled during a ceremony in July 2017.

Marie Corelli's fame has long since faded, but there is no doubt that she was a complex and fascinating woman, full of paradoxes. She also played an important – and entertaining – part in the history of Stratford-upon-Avon.

Cox's Yard and the Attic Theatre

Cox's Yard was once occupied by James Cox & Son, a timber business that moved to the site in 1839, and became well known for supplying fine building material, much of it being used in the area's historic buildings. During the Victorian era there would have been many wharves and warehouses lining the riverbank hereabouts, and the yard, comprising wooden and brick buildings and a tall chimney, was one of the first industries to grow up in the area, with the then new rail and water transport links.

In the twenty-first century the locality has changed out of all recognition, and today Cox's Yard features a family pub with a riverside café and patio. The Grade II-listed building is also home to the Attic Theatre, which occupies a site that dates back to the fifteenth century, allowing it to claim to be the oldest theatre in Stratford-upon-Avon. The old warehouse is timber framed and weatherboarded, and the oak beams from the original structure can still be seen in the auditorium. Voted the 'No 1 Fringe Theatre in Stratford-upon-Avon', the intimate eighty-nine-seat Attic was established in 2009 by award-winning theatre company Tread the Boards. It not only stages a wide range of dramatic and musical entertainments, but also provides workshops and plays to appeal to young children.

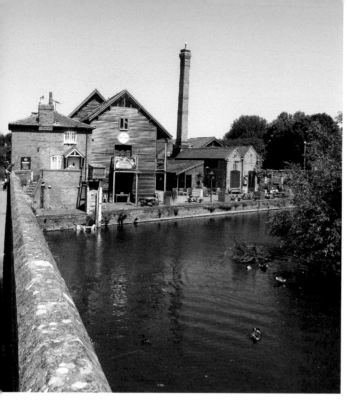

Left: Cox's Yard is seen here from the Tramway Bridge. Once warehouses like this would have lined the banks of the Avon and the canal basin.

Below: The Attic Theatre occupies this weatherboarded building in the Cox's Yard complex.

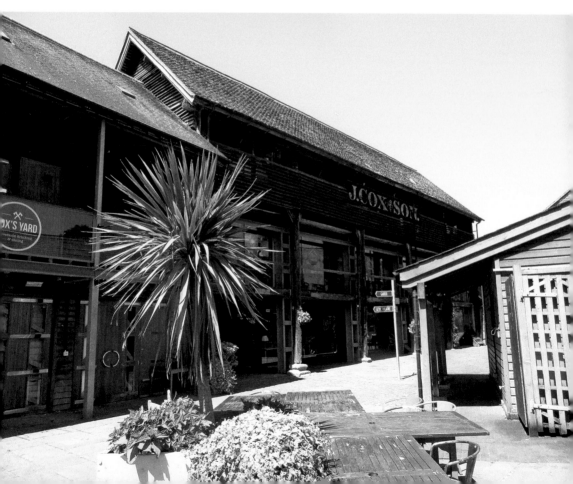

D

The 'Dirty Duck' and Dame Judi Dench

There is probably only one pub in the world where you can sit at a table that has been autographed by Dame Judi Dench. But that is the case at Stratford's famous 'actors' pub' on Waterside.

 The pub was originally called The Black Swan, but its humorous nickname is said to have been given to it during the Second World War by American GIs that were camped on the other side of the Avon – or perhaps by the acting fraternity.

The Dirty Duck in Waterside. On the opposite side of the inn side showing the inebriated waterfowl is a more graceful portrait illustrating the pub's other name, The Black Swan.

There has been a pub here since 1738, and it was known as The Black Swan from at least 1776. It was originally three buildings dating from the fifteenth century; one became a pub, and was joined by the neighbouring house in 1866, the third building being incorporated in 1937. It has been Grade II listed since 1951.

The Dirty Duck has been famously associated with the nearby Royal Shakespeare Theatre (and more recently the Swan Theatre) for many years, and is the place where locals and theatregoers congregate in the hope of glimpsing a famous face. Indeed, *The Telegraph* has dubbed it the 'unofficial licensed extension of the Royal Shakespeare Company'.

Hanging on the walls inside are numerous framed photographs, many of them signed, of well-known actors who have performed at the theatre and visited the pub. There is also the aforementioned autographed table. It was here that actor Peter O'Toole once broke the world record for the time taken to drink a yard of ale, and Kylie Minogue has pulled a pint behind the bar. Other eminent actors who have enjoyed a drink or two here include Richard Burton, Laurence Olivier and Richard Attenborough.

Not surprisingly, the pub is also claimed to have Shakespeare associations. Apparently it was where the young playwright sheltered from Sir Thomas Lucy's men after the famous – and itself probably apocryphal – poaching episode at Charlecote.

More verifiable is the pub's connection with Frank Benson's 'Bensonians' (qv). While sitting in the bar parlour Leonard Parrish, a member of the company between 1910 and 1915, wrote a poem about it, entitled 'Stratford Ale'.

Outside, the sign for the 'pub with two names' portrays a graceful black swan on one side and a drunken duck on the other. It is the only pub in England that has a licence under both of its names.

E

Elizabeth House

Elizabeth House in Church Street is today the headquarters of Stratford District Council (the district being known as Stratford-on-Avon to distinguish it from the town – Stratford-*upon*-Avon – where it is based). The district was formed on 1 April 1974 and covers a large area of south Warwickshire, including the towns of Alcester, Southam and Shipston-on-Stour.

The long frontage of Elizabeth House was built in 1911 for a Dr Henry Ross. Acquired by the NFU in around 1920, it was much extended in the 1920s and 1950s using the local architecture practice of F. W. B. Yorke (qv).

Elizabeth House was built in the William and Mary style in 1911 as No. 15, and was acquired by the National Farmers' Union in around 1920, which expanded it in the same style as the original building in 1927–29, using local architect F. W. B. Yorke (qv). The NFU's Mutual insurance arm still has its headquarters in Stratford, but since the 1980s in the outlying village of Tiddington.

Interestingly, in 1916 an insurance journal said about the five-year-old NFU Mutual (then called the Midland Farmers' Mutual) that 'the company may satisfy some local requirement in the Stratford-upon-Avon district, but we shall be surprised if it makes much progress elsewhere'. How wrong can you be?

Evesham Road Cemetery

This was the first and only municipal cemetery in the town and, then in open country, was laid out in 1881 following a design competition. At that time the parish churchyard at Holy Trinity was almost full. It was intended that funeral services would continue to take place in the church, then the cortege would proceed along Sanctus Street and Evesham Road to the cemetery; to enhance this process an avenue of lime trees was planted in Evesham Road.

The cemetery buildings, comprising a chapel and superintendent's office, were designed with the then fashionable features of arches, turrets and buttresses by architect Thomas Taylor Allen (who died in 1913 and is buried in the cemetery). The matching lodge has mullioned and transomed windows and roofs of fish-scale tiles. The cemetery is surrounded by railings, and it is said that the gates were kept closed to prevent cattle and sheep from straying in when being driven along Evesham Road to market! Local stonemason Jack Clifford worked on the gravestones, as had his father and grandfather before him, and his father's cousin, Charlie Clifford, helped build the chapel, walking more than 8 miles from Ilmington six days a week. The first entry in the register of burials is that of a three-month-old girl named Harriet Hannah Wright, who died in October 1881.

Within forty years of opening the cemetery had to be extended, and in 1939 an area was dedicated to Service War Burials, now under the care of the Commonwealth War Graves Commission. Many of the 177 buried here were Canadians attached to No. 22 Operational Training Unit based at Wellesbourne, and in 1949 a Cross of Sacrifice was unveiled by the Canadian High Commissioner. The cemetery was extended again in 1956, and is today under the care of Stratford-upon-Avon Town Council. It contains many ornate Victorian and Edwardian tombstones, including the stone Angel of the Resurrection adorning the grave of Victorian novelist Marie Corelli (qv).

By the 1970s the cemetery chapel had fallen into disuse, and in 1994 vandals set it on fire. However, a year later it was refurbished and recommissioned.

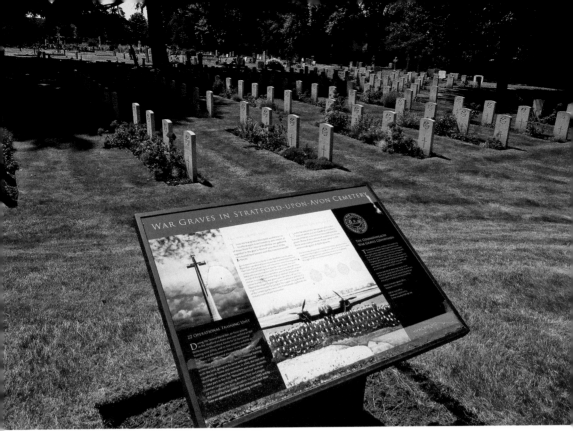

Above: Many of the service personnel buried in the area under the care of the Commonwealth War Graves Commission were Canadians attached to No. 22 Operational Training Unit, Bomber Command, based at nearby Wellesbourne. An information board tells their story.

Right: Vandalised and subsequently restored, the cemetery chapel of 1881 was designed by local architect T. T. Allen and features 'a tiled pyramid tower and an apsed vestry' (Pevsner).

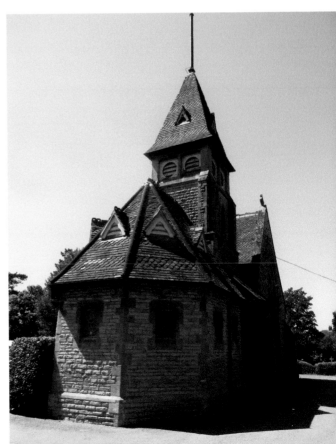

The Flower Family and Flowers Brewery

The slogan 'Pick Flowers' and the company logo featuring a bust of William Shakespeare was once very familiar to beer drinkers in the Midlands. Flowers Brewery became Warwickshire's largest, and by the end of the nineteenth century was Stratford's biggest employer. It was founded by Edward Fordham Flower, who

What remains of the former Flowers Brewery in Clopton Road has been converted into residential units.

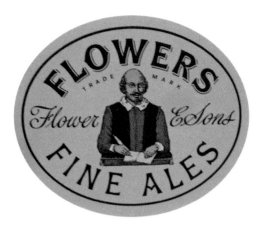

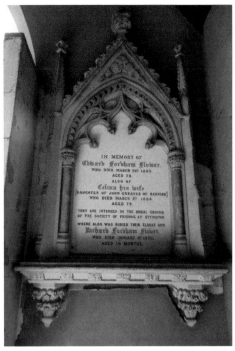

Above: 'Pick Flowers' was the familiar advertising slogan for Flowers Fine Ales and, being Stratford-based, the choice of a trademark image was not difficult!

Right: A memorial to Edward Fordham Flower, his wife Celina and their infant son Richard survives in the Evesham Road Cemetery chapel.

had emigrated with his family from Hertfordshire to the United States. However, his anti-slavery sentiments led him to return to England, where he went into partnership with timber merchant James Cox, of Cox's Yard fame, and married a local girl from Barford. When Edward's father died in 1829, his legacy was invested in a brewery, which opened in 1831. It was immediately successful, and in 1870 larger premises were opened on Birmingham Road.

The brewery earned Flower and his sons considerable wealth, which led ultimately to an enormous influence in the town, in particular the commemoration of Shakespeare. Edward was mayor four times, and in 1864 presided over ambitious celebrations to mark the 300th anniversary of the playwright's birth, some of the costs of which he covered himself.

The oldest of Edward's three surviving sons, Charles Edward, born in 1830, was the key figure in the event, having joined his father as a partner in the brewery in 1852. The celebrations led to thoughts of a permanent theatre, although in some quarters this was met with derision – such plans by mere provincial 'nobodies' were considered 'presumptuous'. Nonetheless, Charles donated a 2-acre site beside the Avon, and in 1875 launched the Shakespeare Memorial Association, an international campaign to build a new theatre. In 1877 the foundation stone was laid, with a further considerable financial input from Flower himself, which led to it being disparagingly referred to as 'the theatre built on beer'. But the philanthropic Charles was sincerely promoting Shakespeare, not himself or his brewery.

Later Edward's youngest son, Edgar Flower, became chairman of the Shakespeare Birthplace Trust, and his grandson Archibald was chairman of the governors of the Shakespeare Memorial and a Life Trustee of the Birthplace. Members of the family controlled the brewery until its takeover and subsequent closure by Whitbread in 1967; it was mostly demolished in 1972. Happily, the Flowers name was revived by Whitbread in the mid-1970s, together with the Shakespeare badge, and today the fascinating Flower archive is held by the Shakespeare Centre Library and Archive.

Levi Fox

Dr Levi Fox OBE DL MA FSA FRHistS FRSL was born in 1914 in Leicestershire and obtained a History degree from Oxford. He was the first city archivist for Coventry and, deemed unfit for war service, was appointed director of the Shakespeare Birthplace Trust (SBT) in 1945, a post he held until 1989. During those four decades the SBT grew in influence and prestige to become an organisation of international repute. Fox gathered a loyal team around him, and demonstrated the kind of entrepreneurial and organisational skills rarely found in an academic.

The SBT depends wholly on visitor income, and during Fox's directorship it acquired important Shakespeare properties, including land around Anne Hathaway's Cottage, Hall's Croft, and Glebe Farm at Wilmcote, adjoining the supposed childhood home of Mary Arden (qv).

In 1964, the 400th anniversary of Shakespeare's birth, the trust opened the Shakespeare Centre in Henley Street next to the playwright's birthplace, which houses its library and archives. Fox worked tirelessly to further the cause of Shakespeare, and served as secretary and deputy chairman of the International Shakespeare Committee, as well as writing many books and articles.

Fox retired in 1989, and his directorship is commemorated by a carved plaque in the foyer of the trust's headquarters. Even in retirement he continued to take great interest in the trust's affairs, and was especially gratified when it was discovered in 2000 that Glebe Farm, which he had helped save from destruction, was in fact the home of Shakespeare's mother, Mary Arden (qv).

For more than forty years Fox was a trustee of Harvard House (qv) and was also chairman of the governors of both the Grammar School for Girls and King Edward VI School for Boys; at the latter the Levi Fox Hall was opened in 1997, named in his honour. A 'contemporary re-interpretation of an English Great Hall of medieval tradition', it can seat 1,000 people for plays and concerts, and is used by both the school and the wider community. Fox was also a founder of the Friends of the Guild Chapel and chairman for fifty years, during which time the building was fully restored.

Levi Fox died in 2006 at the age of ninety-two, and is one of only a handful of people featured in these pages who can truly be said to have left an indelible mark on his adopted town and the worldwide promotion of its most famous son.

G

David Garrick and the Garrick Inn

One of England's greatest actors, and largely responsible for the great revival of Shakespeare's plays in the eighteenth century, Garrick was born in Hereford in 1717, but the family soon moved to Lichfield. He showed an early enthusiasm for the theatre, although upon moving to London he and his brother initially set up a wine business. However, it did not flourish and by 1741 Garrick was appearing as a professional actor, and that year took the title role of Shakespeare's *Richard III* – the naturalness of his performance was noted, as opposed to the somewhat declamatory style of the day. He was later praised for his interpretations of such characters as Romeo, King Lear and Macbeth.

His rise through the theatrical ranks was rapid, and by 1747 he had taken over London's Drury Lane Theatre, and immediately erected a statue to Shakespeare there. He bought a palatial home beside the Thames at Hampton in 1754, and built there a 'Temple to Shakespeare' to house his collection of memorabilia. The promotion of Shakespeare among theatregoers became his greatest ambition, although he was guilty of changing the texts by adding and subtracting scenes!

David Garrick. (Author's collection)

Named in honour of the actor, the Garrick Inn, next door to Harvard House, is probably Stratford's oldest pub.

In September 1769 Garrick staged the Shakespeare Jubilee (see under 'J') at Stratford, which provided an important focus for the emerging appreciation of the dramatist's works, helping to establish him as England's national poet. Oddly, none of the plays were performed, and heavy rain forced a Shakespeare pageant to be abandoned; however, the pageant was staged again more successfully a month later at Drury Lane. The song 'Sweet Flowing Avon' was written for the event, music by Thomas Arne and words by Garrick.

Garrick managed the Theatre Royal, Drury Lane, until his retirement in 1776, and died just three years later; he was buried in Poets' Corner in Westminster Abbey.

Although a giant of the English theatre, talented and convivial, Garrick stood only 5 feet 4 inches tall, and his voice and acting style were relatively subdued compared to the style of the age. A contemporary actor remarked, 'If this young fellow be right, then we have been all wrong.' Much lauded, there were more portraits of him than of King George III himself, and his collection of plays and books helped establish the library of the British Museum following his death. His funeral was one of the grandest until that of Nelson in 1805. Most of all, he helped establish the cult of bardolatry – Shakespeare worship – and put Stratford-upon-Avon on the official Shakespeare map at a time when the small market town was considered to have no significance, despite being the birthplace of England's national poet.

An inn since 1718, the Garrick Inn in High Street was originally The Greyhound, but was renamed in the actor's honour. It is one of the oldest buildings in town – and probably its oldest pub – and is a traditional late sixteenth-century half-timbered structure, though some parts may be as old as the fourteenth century. The inn stands beside Harvard House and has three storeys, with the traditional projecting upper floor. It was reconstructed in 1912 after the removal of a brick façade, then restored in the 1920s and again in 2005.

Gower Memorial, Bancroft Gardens

Lord Ronald Charles Sutherland-Leveson-Gower (1845–1916) was the youngest son of the 2nd Duke of Sutherland. A Liberal MP for Sutherland until 1874, then a trustee of the National Portrait Gallery, and described as 'an aristocratic amateur', he subsequently trained as a sculptor in a Paris studio. His Shakespeare Memorial is his one great work. Unveiled in 1888, it stood originally near the old theatre, but was removed to its present site in 1933. The monument is surmounted by the seated figure of Shakespeare, his left arm resting over the back of his chair and his hand holding a rolled-up manuscript. His right hand once held a bronze quill. At his feet at the four corners of the plinth are four bronze wreaths. Below these on the four pedestals are four bronze masks with foliage and flowers, two tragic and two comic, each symbolic of the character of the additional detached statues of Shakespearean characters that occupy the corners of the monument – Hamlet, Prince Hal, Lady Macbeth and Falstaff – respectively intended to symbolise Philosophy, History, Tragedy and Comedy.

The Gower Memorial has been described as 'probably one of the country's most prominent and best-loved public monuments, seen by thousands if not millions of pilgrims to Shakespeare's birthplace' (Phillip Ward-Jackson).

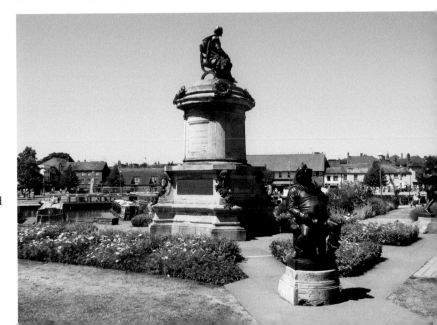

Shakespeare sits atop the Gower Memorial, while in the foreground of this view is a portly Falstaff, symbolising Comedy.

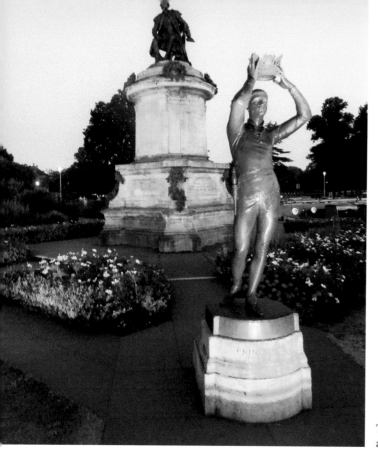

The Memorial is illuminated at night; this is Prince Hal.

Guild Chapel

In 1269 the Guild of the Holy Cross was given permission to build a hospital and chapel in Stratford, and was later responsible for the building of the Guildhall (later the King Edward VI School) and almshouses (both qv) on Church Street.

The chapel, in Chapel Street, stands opposite Shakespeare's final home at New Place, and next door to his schoolroom, so has important associations with the dramatist and his family. In the late 1490s local benefactor Hugh Clopton (qv) gave money for a new nave, porch and tower; the work was incomplete when he died, and his will provided for the chapel's celebrated wall paintings, which when new portrayed saints, the gates of Heaven and Hell, and other aspects of the Day of Judgement in vivid, colourful detail – many small figures are seen climbing from their graves, including a king, a bishop and an abbot.

By the end of the fifteenth century the Guild had become the town's semi-official governing body, but then came the Reformation and under King Edward VI guilds were suppressed and their property confiscated. However, the town still needed a governing authority, so in 1553 the king allowed the setting up of the Corporation of Stratford, which was granted ownership of the chapel.

The Guild Chapel's late fifteenth-century tower and north porch, 'with gargoyles and chunky carvings' (Pevsner).

In 1558 Elizabeth I came to the throne, and the following year she passed an injunction demanding the 'removal of all signs of superstition and idolatry from places of worship'. Chamberlain of the Corporation at that time was John Shakespeare, William's father, and it was his responsibility to put in hand the job of 'defasyng ymages in ye chappell'. For reasons not fully clear, rather than being defaced the paintings were instead largely covered by limewash, an act that was ultimately to lead to their preservation.

In the seventeenth century the chapel was altered by being divided up, and the chancel partitioned to provide tenanted chambers. It was in 1804, during a major refurbishment, that the medieval wall paintings were rediscovered, but then covered over again. By the twentieth century the building was in a poor state of repair and further major works were undertaken, funded by the Friends of the Guild Chapel. It is now part of the estate of the Stratford Town Trust, a charity with origins stretching back to the thirteenth century. Exposed once more, recently the wall paintings have undergone a major conservation project – it is believed that they represent one of the few surviving pre-Reformation medieval schemes painted at the same time as a single work. One conservator is quoted as saying that 'The Guild Chapel wall paintings are an extremely important survival and are of national significance [providing] a visual context for the social and religious attitudes which would have been prevalent at the time of the young William Shakespeare.'

Dr John Hall and Hall's Croft

John Hall (1575–1635) was a respected physician. Educated at Cambridge, he set up a practice in Stratford, where he was the only doctor in the town, and in June 1607 married Susanna Shakespeare (1583–1649), the oldest child of William and Anne. It seems that Hall had a good relationship with his father-in-law – they are known to have travelled together to London on business in 1614. His case notes, published posthumously in 1657, were a popular doctors' textbook for many years. He was known for treating all alike, rich and poor, Catholic and Protestant, and while the doctors of the day tended to practise astronomy or bloodletting, he preferred treatments derived from plants, herbs, animal extracts, gemstones and rocks, and as such was possibly ahead of his time. For example, he prescribed a herbal cure for scurvy a century before doctors recommended the use of limes for its treatment.

Dating back to the early sixteenth century, the main part of Hall's Croft, John and Susanna's Stratford home, was built in 1613 and reflects their wealth and status.

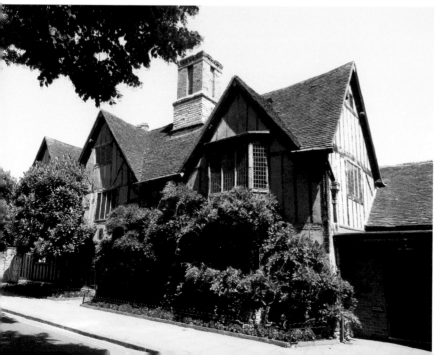

Hall's Croft, the imposing residence of Dr John Hall and his wife, Shakespeare's daughter Susanna.

Originally a relatively small building, it was later enlarged to provide a suitably imposing residence.

When William Shakespeare died in 1616 he left his home at New Place to his daughter, and the couple moved in. Thereafter Hall's Croft became the home of a series of prosperous, often professional people, and in the mid-1800s was serving as a small school. The timber framing was exposed in the early twentieth century, then in 1949 the house was bought by the Shakespeare Birthplace Trust, repaired and refurbished, and opened to the public in 1951; later bay windows and a central porch were removed during the restoration. Now Grade I listed, it contains a collection of sixteenth- and seventeenth-century paintings and furniture, as well as an exhibition about Dr Hall and his medical practices, including a collection of apothecary's equipment and books in the doctor's consulting room, and a 1657 first edition of his medical notes. The walled garden is full of roses and herbaceous borders and still contains the sort of plants, trees and herbs that may well have been used by Hall in his treatments. Shakespeare's plays are sometimes also performed here, and there is a café for visitors.

Sir Peter Hall

The Times's obituary for Sir Peter Hall (1930–2017) described him as 'the most important figure in British theatre for half a century', and the National Theatre stated that his 'influence on the artistic life of Britain in the 20th century was unparalleled'. His specific influence on Shakespeare and Stratford was also huge.

Peter Hall was born in Suffolk, where his father was a stationmaster. Educated at Cambridge University, he produced and acted in a number of plays. Graduating in 1953, he immediately began to produce plays professionally. From 1954 to 1955 he was director of the Oxford Playhouse, then in 1955–57 he ran London's Arts Theatre.

Hall made his debut at the Shakespeare Memorial Theatre in 1956 with *Love's Labours Lost*. Then in 1960, aged only twenty-nine, he was appointed director of the theatre, expanded operations to last all-year round and, most importantly, founded the Royal Shakespeare Company (RSC). His vision was for a permanent company of actors, directors and designers to produce both modern and classical pieces with a distinctive and individual style. Theatre critic Michael Billington described Hall's radical plan as 'turning a star-laden, six-month Shakespeare festival into a monumental, year-round operation'.

The RSC was formally established on 20 March 1961, and it was also announced that henceforth the Shakespeare Memorial Theatre would be known as the Royal Shakespeare Theatre, and the new company the Royal Shakespeare Company.

Among Hall's many RSC productions, perhaps the most significant was *The Wars of the Roses* in 1963, an ambitious adaptation of Shakespeare's history plays by Hall in collaboration with eminent Shakespeare director and scholar John Barton. It was

described as 'the greatest Shakespearian event in living memory which also laid down the doctrine of Shakespearian relevance to the modern world'. Hall was in charge of the RSC for almost ten years, leaving in 1968 and handing the baton to Trevor Nunn.

Surprisingly, there was some opposition from the National Theatre when the RSC sought to establish a London base. Nonetheless, this came about with the RSC moving into the Aldwych Theatre, its stage being redesigned to match Stratford's apron stage.

Gregory Doran, RSC artistic director in 2018, said of his predecessor, 'Sir Peter Hall was a colossus, bestriding the British theatre. He was a visionary [and] a politician who fought for the Arts. It is impossible to single out his greatest production. But his greatest legacy without doubt will be judged to be the formation of the Royal Shakespeare Company in 1961.'

Harvard House

Once known as 'the Ancient House', this three-storey house in High Street, with its elaborately carved timber façade (never plastered over or painted black), was built by Thomas Rogers in 1596, following the Stratford fire of 1594. His initials, those of his second wife, Alice, a bull's head (to denote his trade) and the date of construction are

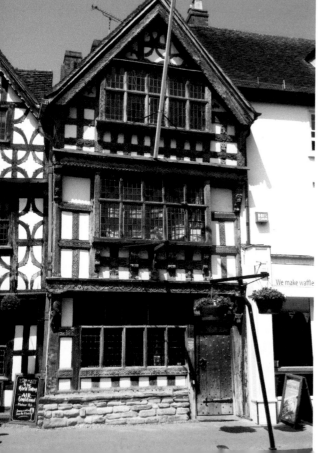

The very ornate frontage of Harvard House dates from 1596 and was restored in 1909 under the influence of Marie Corelli. The building now belongs to Harvard University.

The house was built by wealthy butcher and grazier Thomas Rogers, whose initials can be seen carved into the timbers.

carved on the front. Rogers was a successful and wealthy butcher and grazier, and served as an alderman in Stratford with John Shakespeare, William's father. When he died in 1611 he left the house to his son, also Thomas, a maltster; he in turn left it to his son, Edward Rogers, a bookbinder. The family sold the house in the mid-1660s.

In 1605 Thomas Rogers's daughter Katherine married Robert Harvard of Southwark in south London. Southwark was a centre of theatre at that time – the famous Globe theatre was located there – so it is possible that Robert Harvard knew William Shakespeare, and may have met his Stratford-born wife through him. Katherine and Robert were married in Stratford and their son John was born two years later. Educated at Cambridge, John became a minister and in 1636 married Ann Sadler. The following year they emigrated to Massachusetts, where John worked briefly as a preacher and teacher before succumbing to tuberculosis in 1638.

Meanwhile the Massachusetts Bay Colony had founded a college in what was originally known as Newtowne, but was renamed Cambridge as many colonists had been educated at that university. On his death, John Harvard was wealthy enough to be able to bequeath £750, half of his estate, and his library to the college, which in gratitude named it after him in 1639. Harvard University is today one of the USA's most prestigious seats of learning, and its oldest.

Because of its age and its unique connection with America, in 1909 novelist Marie Corelli (qv), always keen to preserve elements of the town's heritage, suggested that the house might be purchased by Everard Morris, a Chicago millionaire. That done, and after extensive restoration, it was presented to Harvard University and became known as Harvard House, for use by students and visiting Americans. As Miss Corelli said, 'You may call it a romantic notion perhaps, but I should like to think that the house of John Harvard's mother was a link with John Harvard's University, and a sign of friendship between the two nations.'

Harvard House has been cared for by the Shakespeare Birthplace Trust on the university's behalf since 1990.

Anne Hathaway

The marriage of Anne Hathaway and William Shakespeare in November 1582 has been the subject of a certain amount of speculation, little of it proved with certainty. Even Anne's name is in doubt, as in her father's will she is referred to as 'Agnes'. What is known is that the groom was eighteen and the bride twenty-six, and that she was already pregnant with their first child. One suggestion is that he was due to marry someone else, but Anne's pregnancy forced him into a 'shotgun wedding' and that he held it against her for the rest of their married life – which may have been one reason why he left Stratford to pursue his career as a playwright. However, there is really no substantial evidence to support this.

Conversely, Germaine Greer argues that it was William who pursued Anne, and that women such as her, who looked after the family following her father's death (the year before the marriage, in 1581) often married in their late twenties. Also, the Hathaways were a well-respected family while the Shakespeares by this time had fallen on harder times, so she might have been considered 'a good catch'. Greer also argues that at the time many brides were already pregnant when they married, and that autumn was a more popular time for weddings than spring, so there is little likelihood that William was not committed to the marriage.

Susanna was duly born in 1583, and twins Hamnet and Judith in 1585; Hamnet died aged eleven in 1596 during one of the outbreaks of plague. (The twins were named after their parents' friends Hamnet and Judith Sadler; Hamnet was a Stratford baker.) Apart from documents relating to her marriage and the births of the Shakespeare children, there are no other recorded references to Anne during her lifetime. Susanna married local doctor John Hall in 1607, and the following year Judith married vintner and tavern owner Thomas Quiney (both qv).

Despite suggestions that William grew to dislike Anne – and it is true that for most of their married life he lived in London, writing and acting, while she remained in

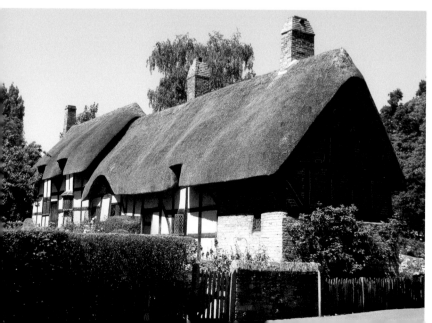

The classic view of Anne Hathaway's Cottage in its quintessentially cottage garden setting.

Stratford – it seems he returned to the town for a time each year, and retired to Stratford and his wife rather than staying in the capital.

When William died in 1616 John and Susanna Hall were his executors and, after all other bequests, they inherited 'all the rest of my goods, chattels, leases, plates, jewels and household stuff whatsoever', as well as his house at New Place, which might explain why his widow famously received only his 'second-best bed, with the furniture', something that has historically been regarded as a slight against her. Another interpretation is that the second-best bed would have been their marriage bed, since the best one was typically reserved for guests.

Anne herself died in 1623 at the age of sixty-seven and was buried next to her husband in Holy Trinity Church. (Again, it has been suggested that Shakespeare's request that his tomb be not disturbed was to prevent his wife from joining him within it!)

Anne Hathaway's Cottage at Shottery, built by the Hathaways in the late fifteenth century and where it is supposed she grew up, is today a major Shakespearean tourist attraction; indeed, it had already become a place of literary pilgrimage by the late eighteenth century. A spacious twelve-roomed house rather than a cottage, it is today set in a quintessentially English cottage garden. The house stayed in the Hathaway family until 1846; it was then sold, but they continued to occupy it as tenants until 1892, when it was acquired by the Shakespeare Birthplace Trust. The trust removed later additions and alterations, and also acquired surrounding land to protect its setting. In 1969 it was badly damaged in a fire, but was restored.

Holy Cross Almshouses

The word 'alms' derives from a Greek word meaning 'compassion', and referred to relief given out of pity to the poor; in turn an almshouse was a building endowed for the support of the poor, those unable to work by reason of age or poverty. In Stratford ten almshouses were built in Church Street in 1427–28 by the Guild of the Holy Cross (whose chapel they adjoin – qv), originally for the accommodation of old or needy members of the guild itself. Apparently rebuilt in the early sixteenth century, they survived the Reformation, and in 1553 were transferred to the town's Corporation and enlarged to provide more than twenty almshouses for twenty-four elderly townsfolk.

In the seventeenth century the rules required the residents to attend the chapel on weekdays and go to church on Sundays, unless prevented by illness. Drunkenness, quarrelling or swearing could lead to the withdrawal of the offender's pension. By the early nineteenth century the twenty-four almspeople were half men, half women, the latter mostly widows; they had to be Stratford residents and preferably elderly, and were chosen by ballot. Stoves were provided, but residents had to bring their own furniture. By 1881 there was a resident matron, and the former occupations of the residents varied enormously from labourer to schoolteacher.

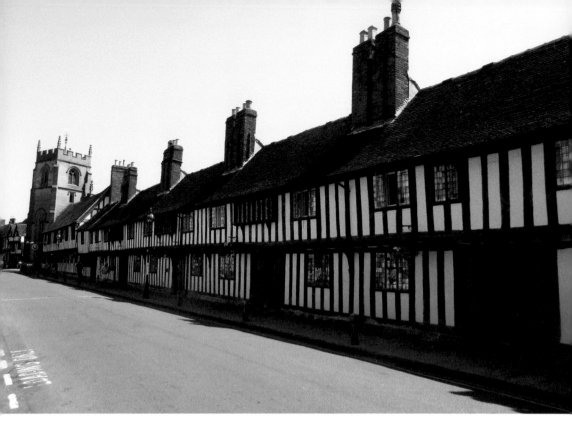

The lengthy timbered frontage of the Holy Cross Almshouses in Church Street, with the tower of the Guild Chapel beyond.

Now Grade I listed, the building is timber framed with a plaster infill on a stone plinth. It is thought that the ground-floor rooms were occupied by elderly married couples, and were entered from the street or garden, while the upper rooms accommodated single or widowed elderly people, accessed from a gallery that ran the whole length of the rear.

The almshouses have been much altered over the years. They were restored in 1892 by Charles Flower, and refurbished, modernised and extended in 1981–84; nonetheless the survival of original features is notable. In the listing document, Historic England says, 'The use of so much timber in the close-studded walling, a bracketed jetty and the oriel windows all mark this as a prestigious project with accomplished carpentry.' Today there are eleven units behind the 150-foot (48-metre) frontage, each with its own kitchen and bathroom, together with a communal lounge and garden at the rear.

Holy Trinity Church

What has become known as 'Shakespeare's Church' – more properly the Collegiate Church of the Holy and Undivided Trinity – is Stratford's parish church. Famous for centuries as the location of the baptism and burial of William Shakespeare, it is visited by hundreds of thousands of people every year.

Stratford's oldest building, the church was built on the site of a ninth-century Saxon monastery, and the earliest surviving parts are the early thirteenth-century transepts. In the 1320s the nave and north and south aisles were rebuilt, and the tower raised; the church is thought originally to have had a wooden spire, replaced in the mid-eighteenth century by the present Gothic stone example.

Particular features of interest include a fourteenth-century sanctuary knocker in the early sixteenth-century porch, twenty-six misericord seats in the chancel (ledges projecting from the underside of seats giving support to anyone standing when the seat is hinged up), and impressive stained-glass windows. Despite desecrations following the Reformation, some medieval stained glass survives, depicting the Resurrection and Ascension of Christ and the Day of Pentecost. A pre-Reformation stone altar slab, hidden beneath the floor, was rediscovered and reinstated in the nineteenth century. As with many English churches, most 'restoration' and alteration work was undertaken in the Victorian era.

Of course, what most people come to see is the tomb of the great playwright. Shakespeare was baptised in the church on 26 April 1564 and was buried there on

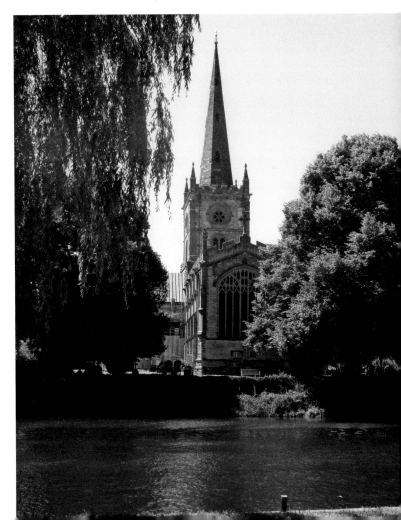

The chancel and spire of Holy Trinity Church viewed from the east bank of the Avon.

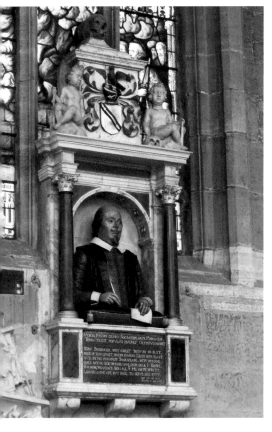

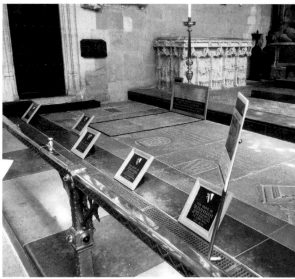

Above: The graves of (left to right) Anne and William Shakespeare, Thomas Nash, and John and Susanna Hall in the chancel at Holy Trinity.

Left: Nikolaus Pevsner considers that Shakespeare's famous alabaster demi-figure funerary monument makes the bard 'look like a self-satisfied schoolmaster'.

25 April 1616. The tomb is in the fifteenth-century chancel – after the Reformation the church's former rights to collect tithes were sold off, and in 1605 Shakespeare purchased a share in them, which is thought to have given him the right to be buried in the chancel. His well-known funerary monument is on a wall alongside; it was renovated in 1746 using proceeds from a performance of *Othello*, the first recorded performance of one of Shakespeare's plays in the town. William's wife Anne is buried next to him, as is their eldest daughter, Susanna; Thomas Nash, the first husband of Shakespeare's granddaughter Elizabeth, is also here.

Above the grave there is a very eroded stone slab, on which is carved his famous epitaph:

> GOOD FRIEND FOR JESUS SAKE FOREBEAR,
> TO DIGG THE DVST ENCLOSED HERE.
> BLESTE BE YE MAN YT SPARES THESE STONES,
> AND CURSED BE HE YT MOVES MY BONES.

The reason behind so stern a warning has been debated for centuries.

I

Sir Henry Irving

John Henry Brodribb was born in 1838 in Somerset and spent some of his childhood in Cornwall. Later, living in London, he worked as a clerk, but his heart was set on the theatre. A £100 legacy in 1856 allowed him to buy props and costumes, and to buy himself a part in an amateur production of *Romeo and Juliet* at the Royal Soho

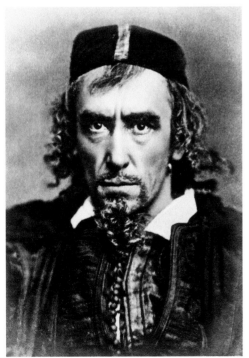

Above left: Irving specialised in the macabre and the melodramatic on stage, as suggested by this portrait of him as Shylock in *The Merchant of Venice*. (Commercial postcard, author's collection)

Above right: From 1878 Irving formed a professional partnership with actress Ellen Terry as his leading lady, seen here as Beatrice in *Much Ado About Nothing*. (Commercial postcard, author's collection)

Theatre, under his new stage name of Henry Irving. He was soon a member of a touring theatrical stock company, a great apprenticeship for an aspiring actor. In three years he played more than 400 different parts in 330 plays, including most of Shakespeare's works.

By the 1870s he was recognised as one of the leading classical actors of his day, his on-stage presence specialising in the macabre and the melodramatic. In 1874 he played Hamlet for the first time, and in 1878 became manager of London's Lyceum Theatre. There he and his company were feted for the quality of their productions, even though to modern tastes his performances would have felt over-mannered, albeit visually striking, and his diction 'more curious than melodious' (John Russell Taylor). From 1878 he formed a professional partnership with actress Ellen Terry as his leading lady, and they appeared together in Shakespeare plays as Hamlet and Ophelia, Shylock and Portia, etc. They gave the public the spectacle and drama they craved, and drew enormous audiences.

In 1887, to mark Queen Victoria's Diamond Jubilee, Irving was invited to Stratford to unveil the American Fountain in Rother Street (qv). He was, after all, the most celebrated actor of his day, and had also successfully taken several Shakespeare productions to the USA.

In 1893 Irving claimed that his favourite parts were Hamlet, Richard III, Iago and King Lear; he was drawn to characters who embodied the idea of the divided self, who showed one face to the world of the play and an inner self to the audience.

In 1895 Irving became the first actor to be knighted, but by the end of the decade his health was failing and, without him on stage, his company's box office receipts fell. A new production of Shakespeare's *Coriolanus* proved unsuccessful, and in 1902 Irving's reign at the Lyceum came to an end. Following a performance in Bradford in 1905 he suffered a stroke and died.

The following year Cambridge University Press published Irving's own critical edition of Shakespeare's works, seen through a performer's eyes.

J

The Jester

This lively statue in Henley Street was commissioned in 1994 by Anthony Bird OBE (managing director of the property development and manufacturing company Bird Group) as 'a token of his esteem for the town in which he was born, lives and works and which has given him so much friendship, good fortune and pleasure'. The statue is in bronze on a stone plinth and depicts the jester 'Touchstone' from Shakespeare's *As You Like It*. Inscriptions include 'O noble fool! A worthy fool' and 'The fool doth think he is wise but a wise man knows himself to be a fool.' He holds the mask of comedy on a stick (a 'poll') in his left upraised hand, while his right hand is behind his back concealing the mask of tragedy.

The sculptor was James Butler MBE (b. 1931), who lives and works in Warwickshire. He said, 'The character of the Fool or Jester appears in many Shakespeare plays and

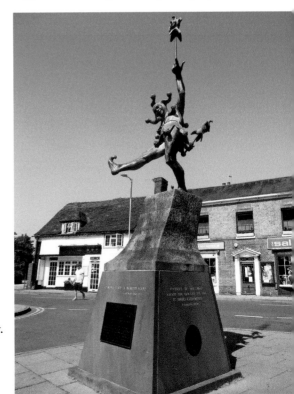

'O noble fool! A worthy fool!' This quotation from *As You Like It* appears on the plinth beneath James Butler's cheery 'Jester', a representation of Touchstone from that play.

I decided to portray him dancing – almost leaping off his plinth. He is holding two polls. One is smiling, one is grim. They represent the symbols of drama.' International mime artist John Mowat danced and struck various poses to inspire the final form of the statue.

James Butler is no stranger to Shakespeare. In the late 1960s and early 1970s he worked with the RSC creating statues for *Julius Caesar*, *Coriolanus* and other productions. As well as prominent works both here and abroad, he also designed the 'Jubilee' coin and the 50 pence piece that commemorated Roger Bannister's four-minute mile.

The Jubilee of 1769

The Shakespeare Jubilee took place in Stratford between 6 and 8 September 1769. It was the first such event to celebrate Shakespeare's life and works (albeit five years after the bicentenary of his birth), and was organised by the actor David Garrick (qv). It is recognised as having had a major influence on the establishment of Shakespeare as England's national poet, and the growth of what became known as 'bardolatry'. It was also a crucial moment in Stratford's history, beginning its development as a tourist destination.

The festival arose from an approach to Garrick, as the country's most famous Shakespearean actor, by Stratford's leaders to help fund a statue of Shakespeare to stand in their new Town Hall (qv). In response Garrick planned a major celebration that would be attended by the great and the good of the day, and as a centrepiece he oversaw the construction of a large riverside rotunda on the Bancroft capable of holding 1,000 spectators. The Corporation responded by giving Garrick the freedom of the borough, presented in a box made from the wood of Shakespeare's mulberry tree from New Place.

On the opening day thirty cannons were fired, church bells were rung, and the town was thronged with visitors. After various events commemorating Shakespeare's life, 700 people sat down to a meal in the evening. Unfortunately, torrential rain on the 7th disrupted the proceedings, and the rising river flooded streets and parts of the rotunda. Nonetheless the new statue was unveiled at the Town Hall, and although the evening's firework display was a washout, a masked ball was held in the evening. On the third day a Shakespeare pageant had been planned, but the rain forced its cancellation – it was later staged at Drury Lane, where it was a great success. Most people were now clamouring to leave the town, missing a horse race for the 'Jubilee Cup' (qv Racecourse). The diarist James Boswell wrote, 'After the joy of the Jubilee came the uneasy reflection that I was in a little village in wet weather and knew not how to get away.' Strangely, perhaps, none of Shakespeare's plays were performed during the event!

Many ridiculed Garrick's self-promoting venture; he himself considered the festival a failure, and never returned to the town. He suffered a financial loss, only recouped when the pageant was presented at Drury Lane. He was therefore unsympathetic to a proposal that a Shakespeare Jubilee should be held annually, and it was not until 1816 that such an event was again staged, with a ball, public banquets and a firework display to mark the bicentenary of Shakespeare's death.

K6 Telephone Kiosk

Possibly Stratford's most unusual 'listed building' is a red telephone box outside the Swan Theatre on Waterside.

The K6 kiosk was designed by Sir Giles Gilbert Scott to commemorate King George V's Silver Jubilee in 1935; it is constructed of bolted-together cast-iron sections with a domed roof and a concrete base. Three sides are glazed, one side being a door. By 1960

Stratford's smallest 'listed building' is this K6 telephone kiosk outside the Royal Shakespeare Theatre in Waterside. Beside it is a Victorian postbox.

some 60,000 had been installed across the country, and nearly 12,000 still remain, more than 2,000 of which have been listed; they must therefore be preserved, and many have been adopted by local communities – without the telephone equipment – to be turned into galleries, information booths, wildlife centres and miniature libraries, among other uses.

Stratford's example was listed in 1987, and the listing entry describes it as 'Square kiosk with sail-vaulted roof. Relief crowns to top panels, above renewed painted glass panels reading: TELEPHONE'.

King Edward VI School and Former Guildhall

The Grammar School of King Edward VI occupies a site where there has been some kind of educational establishment since the thirteenth century. It was founded by the Guild of the Holy Cross, and refounded in 1553 when the provision of a school was

King Edward VI School is on Church Street, between the Guild Chapel and Holy Cross Almshouses. It was formerly the Guildhall, where the town council met.

a condition of Edward VI's charter establishing Stratford as a borough. The school occupied the upper floor of the Guildhall in Church Street.

The Guildhall was where the Town Council met, and also where travelling players performed on a temporary stage, the fixings of which are still visible. After 1864 the whole building became part of the school, and the Guildhall is now open to the public, as well as used for teaching.

Until 2013 it was a boys-only school, and there is a good chance that young William Shakespeare studied here between the ages of seven and fourteen – it has therefore justifiably dubbed itself 'Shakespeare's School'. Because William's father John was a bailiff of the borough, and mayor in 1568, his son would have been entitled to a free place.

Since 1893 pupils and masters have led an annual procession through the town from the school to Holy Trinity Church to lay flowers on Shakespeare's grave. In 1982 the 500th anniversary of the endowment of the school by the priest Thomas Jolyffe was celebrated, and in 2003 the 450th anniversary of the school's refounding was marked.

Such is the age of the school that its buildings range from the fifteenth century to the Denis Dyson science building opened in 2008. There is also the Levi Fox Hall of 1997 (Fox – qv – having been chairman of the governors), which is used for sport, assemblies, school plays, concerts and examinations.

The Guildhall and Guild Chapel form three sides of a small courtyard, which is completed by what is known as the 'Pedagogue's House' (pedagogue being an old Middle English word for a teacher). It is documented that a schoolhouse was under construction in 1427–28, and is one of the earliest timber-framed school buildings in the country for which the building accounts survive; remarkably, dendrochronology of the building's timbers has revealed that the trees were felled in 1502. Adjoining it is the eighteenth-century Old Vicarage (the headmaster's house since the 1870s), and the Guild Chapel (qv), which is used by the school for morning service and other school events.

The Library

The Scottish-born American philanthropist and millionaire Andrew Carnegie made his fortune in steel, and donated some £70 million to found libraries throughout Britain and the USA, among many other things. In 1902 Archibald Flower, of the brewing family, asked him to fund a free library in Stratford, and he agreed. The site

Stratford's Public Library occupies restored buildings of sixteenth-century origin that were saved from demolition by the intervention of Marie Corelli.

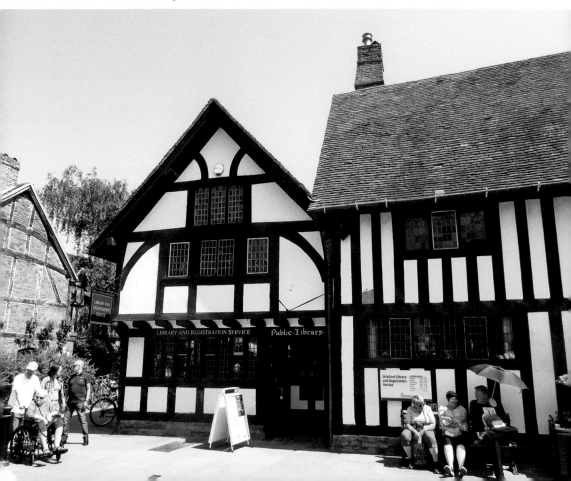

In the doorway is a plaque commemorating the fact that the library was the gift of American industrialist and philanthropist Andrew Carnegie in 1905.

that was chosen was close to Shakespeare's Birthplace in Henley Street, and five late fifteenth-century cottages were to be pulled down to make room for it.

At this point novelist Marie Corelli entered the fray, protesting against the demolition of the cottages, claiming that one of them had been occupied by Elizabeth Hall, Shakespeare's granddaughter. She felt that it would be sacrilege to place a modern building so close to the birthplace; she is reported to have described Henley Street flamboyantly as 'the centre aisle of the cathedral of literature'. The subsequent war of words led to a celebrated libel case; she won, but was awarded only a farthing in damages. It was subsequently established that two of the five cottages had indeed belonged to Elizabeth, and Corelli was able to claim that the library trustees had no 'power or right to sell or destroy any property that had belonged to William Shakespeare or any member of his family'.

Despite this recent incomer's perceived 'meddling' in Stratford's affairs, and making many enemies in the process, Corelli's enthusiastic championing of the town's heritage resulted in the cottages being reprieved. Indeed, it was the first example of a local conservation campaign. The cottages were duly restored and extended ready for opening as a library in 1905; also incorporated was the former Technical School, established in 1899 by the Flower family.

The following year Corelli published her novel *God's Good Man*, which was set in the fictitious Riversford, but was clearly Stratford, and some characters were based on the protagonists in the library controversy.

Stratford's Carnegie library is unusual as it was not a new building, as was the case elsewhere, the funding instead being used to convert existing buildings. The library was awarded Grade II listing in 1972.

Mason Croft

Behind Mason Croft's elegant eighteenth-century town house façade is a collection of much older buildings. The site was once two houses, owned by the Bartlett family. In 1698 Ann Bartlett married lawyer Nathaniel Mason. In 1710 they began to create a larger, more modern house, and in 1727 bought the house next door. Their son Thomas acquired further adjoining property and land, and more building and improvements continued until his death in 1748. The house remained in the Mason family until 1867. In 1874 it was bought by Dr John Day Collis, who was founder and headmaster of Trinity College School next door, and Mason Croft was used for teaching purposes.

In 1900 novelist Marie Corelli, a newcomer to Stratford, rented the house with her companion Bertha Vyver – its Tudor origins appealed to her veneration of all things Shakespearean. In 1901 she bought the house outright and she and Bertha lived there until Corelli's death in 1924. Bertha wrote, 'It was a dilapidated old place when we went in, but together we set to work, and in good time it was improved out of all recognition.' The large music room fireplace features the intertwined initials 'M.C.' and 'B.V.' and the motto 'Amor Vincit' – 'love conquers'.

Here Corelli entertained many literary celebrities, but insisted on 'no actors'! Happily, her prejudice against the theatrical profession no longer persists, as members of the Royal Shakespeare Company are among the building's regular visitors. On her death Corelli left her estate to Bertha, and instructed that the house become a trust

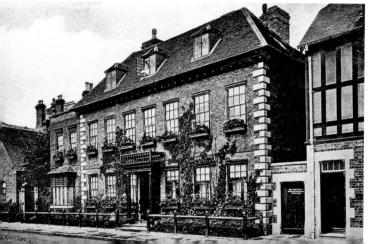

This postcard view shows Mason Croft when it was home to Marie Corelli and Bertha Vyver. Bought by them in 1901, 'after a few years, during which shrubs and creepers grew outside and alterations were made within, it became the charming and homely house that it is today,' wrote Bertha. (Commercial postcard, author's collection)

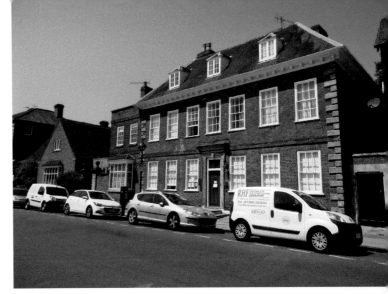

Mason Croft as it is today, owned by the University of Birmingham.

In 1874 Mason Croft was bought by Dr John Day Collis, founder and headmaster of Trinity College School next door. The school building survives, as seen here. Dating from around 1720, the upper floor and pediment, with commemorative plaque, were added in 1872 when it became a school.

'for the promotion of Science, Literature and Music among the people of Stratford upon Avon'. Bertha kept Mason Croft exactly as it was in Corelli's lifetime, almost as a museum – every object that had last been touched by her was left in situ. However, lack of money led to increasing dilapidation, and during the Second World War the music room was requisitioned by the WAAF. Bertha Vyver died in 1941, the trust was declared void and all Corelli's possessions sold off at knock-down prices.

After the war the house became the temporary home of the British Council, then in 1951 it was listed Grade II and bought by the University of Birmingham as the home of the university's Shakespeare Institute. Much is still as it was in Corelli's day, with the addition of a purpose-built research library, opened in 1996, to house the university's Shakespeare collections, and attracting scholars from all over the world.

Mop Fair

The fair was first granted a royal charter by King Edward VI in 1554, with further charters by James I and Charles II. The latter, dated 31 August 1676, provided that the 'mops' or fairs should be held 'within and through all places Streets, Lanes, Alleys and Fields in the said Borough'.

Stratford's position at the crossing of the Avon encouraged its growth as a market town and as a focus for employment. Agricultural labourers and domestic staff worked from October to October, and at the end of each working year they would go to the 'Mop Fair' in their best clothes, carrying an item signifying their trade, in the hope of being rehired – a shepherd might carry a crook, a farm labourer a piece of plaited hay, and a waggoner some whipcord in his hat, while a maidservant might carry a broom. A servant with no particular skill would carry a mop head, hence the event's popular name. Once hired on mutually agreed terms, the employer would give his new servant a small monetary retainer, and they would then replace the sign of their trade with a bright ribbon to show that they had been hired – before spending the retainer on food and entertainment at the fair.

In Stratford the fair is held annually in the centre of town on 12 October (unless it is a Sunday), bringing all streets to a standstill until it closes at midnight, whereupon it immediately disappears. In recent times it has become principally a funfair featuring both traditional and modern attractions. The 'Runaway Mop' takes place a week later, and originally gave both parties time to reconsider the hiring agreement before starting the year's engagement.

The Mop is traditionally opened by the mayor, who holds a pig or ox roast beforehand – about the only feature of the original fair that survives today. He is then led around the fair by the Master of the Mop, and chooses a ride to go on. On the first morning of the fair (the 'Charity Mop') local children are able to enjoy the rides for free.

In 2003 the district council held a local referendum to see whether the Mop should move out of town to reduce the noise and disruption. Happily 68 per cent felt it should remain in its current location, and 81 per cent regarded it as an essential part of the town's heritage. The council therefore concluded that it should continue unchanged, and hopefully will do so for many years – maybe centuries – to come.

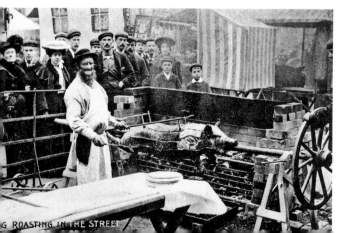

Roasting a pig or ox in the street is one of the few traditions surviving from the original Mop Fair. This old postcard shows a pig on a spit, with what looks like plenty of good crackling! (Commercial postcard, author's collection)

N

Nash's House and New Place

Two houses that stand – or, in the case of one of them, stood – in Chapel Street have strong Shakespearean connections. Grade I-listed Nash's House was built around 1600 and belonged to Thomas Nash, first husband of Shakespeare's granddaughter Elizabeth.

Reputedly the second largest house in Stratford, New Place was built in 1483 by Sir Hugh Clopton (qv). Built of brick and timber, it boasted ten fireplaces and was surrounded by land large enough to include two barns and an orchard. The house remained in the Clopton family until 1563, then passed through several hands until it was sold to William Shakespeare in 1597 for £60. Initially there was some legal difficulty when it transpired that the former owner had been poisoned by his son, which meant that his property, including New Place, was forfeit to the Crown. However, the alleged murderer's younger brother came of age in 1602, his father's properties were returned to him, and the sale to Shakespeare was confirmed.

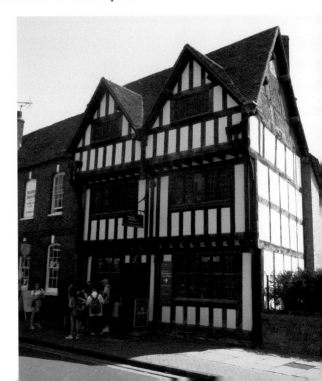

Nash's House was the home of Shakespeare's daughter Elizabeth and her first husband, Thomas Nash, although the frontage seen here dates from a restoration of 1912.

The adjoining garden is the site of New Place, Shakespeare's final home, controversially demolished in the mid-eighteenth century. It had formerly been one of the grandest houses in the town.

Shakespeare lived at New Place until his death in 1616, in retirement for the last few years of his life, and it is here that he is believed to have written his later plays, including *The Tempest*. In the garden was a mulberry tree, reputedly given to him by King James I in 1608, soon after Shakespeare's granddaughter Elizabeth was born. On his death he willed the house to his daughter Susanna and her husband, Dr John Hall. It then passed to their daughter Elizabeth, who had married John Barnard of Abington, Northampton, following the death of her first husband. Then, when Elizabeth died childless, the house was returned to the Clopton family.

In 1702 New Place was radically altered, then in 1756 its then owner, Revd Francis Gastrell, or his wife, fed up with tourists peering over the garden wall, is said to have destroyed the famous mulberry tree. Stratford townsfolk retaliated by breaking his windows. When Gastrell applied for permission to enlarge the garden, it was rejected and his tax was increased, so Gastrell controversially pulled down New Place in 1759. So outraged was the town that the reverend gentleman was forced to leave, moving to Lichfield!

In 1876 the site and Nash's House next door were acquired by public subscription by the Shakespeare Birthplace Trust; Nash's House is now a museum tracing the history of the town, and also the entrance to New Place next door. In 1920 a beautiful and intricate knot garden was created by public subscription as a war memorial. For 2016, marking 400 years since Shakespeare's death, the rest of the garden was redesigned in four zones, reflecting the lines of the lost house and the use of the buildings known to have existed. There have also been important archaeological digs, including one featured on TV's *Time Team*, which have revealed some idea of what the house might have looked like in Shakespeare's day. The only known drawing was one done from memory following its destruction.

O

The Old Bank, Chapel Street

The private bank of Tomes, Chattaway & Ford was established in Stratford 1810 and was later taken over by the Stourbridge & Kidderminster Bank, which operated between 1834 and 1880. In the latter year the S&KR was in turn absorbed by the Birmingham Banking Company, which built these impressive premises in 1883, designed by Birmingham architects Harris, Martin & Harris in red brick and terracotta. Pevsner considers it 'Stratford's best Victorian building'.

It is distinguished by the mosaic portrait of William Shakespeare above the main entry door, based on the design of the playwright's memorial bust in Holy Trinity Church. There are also reliefs depicting scenes from Shakespeare's plays by Samuel Barfield of Leicester.

The red-brick and terracotta Old Bank of 1883 has an angled turret with a pyramid roof on the corner of Chapel Street and Ely Street, opposite the Town Hall.

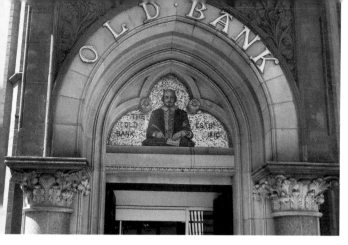

A closer view of the mosaic of Shakespeare by Antonio Salviati, based on the dramatist's monument in Holy Trinity Church.

Terracotta reliefs showing scenes from Shakespeare's plays adorn the Chapel Street face of the building.

The mosaic is the work of Antonio Salviati (1816–90), an Italian glass manufacturer and founder of the Salviati family firm. He trained as a lawyer, but became interested in glasswork after participating in the restoration of mosaics in St Mark's Cathedral, Venice. He opened his first glass business in 1859, and it produced the mosaic glass for the altar screen and high altar of Westminster Abbey. His business eventually became the first glass factory to mass produce glass for export, and re-established Murano, near Venice, as a centre of glass manufacturing. Salviati's mosaics can be seen in many churches internationally, so his work on this bank may be seen as quite unusual.

The Other Place

The Other Place is described by the Royal Shakespeare Company as 'a creative hub for learning, research and development with rehearsal rooms and a 200-seat studio theatre'. Located beside the Avon in Southern Lane, it also features the company's extensive costume store, theatre tours, and a café bar. Each year the venue hosts

The central gabled building was formerly the entrance to the Courtyard Theatre, while the auditorium, backstage and dressing rooms are in the brown corrugated building on the right.

two festivals of new work. Local amateur groups are also able to use the theatre for rehearsals and performances, and it is available for commercial hire.

The Other Place began life as a corrugated tin shed rehearsal room, then in 1974 it was converted into a studio space, the brainchild of Buzz Goodbody, who was also its artistic director in its early days, making it 'the most productive tin shed in theatre history'! He created an unconventional auditorium, which aimed to engender a sense of community and intimacy between actors and audience, putting on exciting small-scale contemporary and experimental work.

In 1989 the venue closed for rebuilding, emerging in 1991 as a permanent modern brick building, but remaining true to the spirit of the original. It continued to produce exciting productions as well as welcoming overseas companies, holding workshops and teaching courses, and hosting conferences on all aspects of theatre, including the annual Prince of Wales Shakespeare School.

This building in turn closed in 2005 to be adapted as a foyer to the temporary Courtyard Theatre, built on the adjacent car park, which allowed the RSC to continue its programme of performances during the transformation of the main and Swan theatres between 2006 and 2010. Thereafter the shell of the Courtyard Theatre's auditorium was extended and remodelled to become the present Other Place. Redevelopment began in 2015 and it opened in 2016, the 400th anniversary of Shakespeare's death.

Other Stratfords!

Australia boasts two Stratfords-upon-Avon! That in Victoria is located on the River Avon and is believed to have been named after its Warwickshire namesake (although the explorer and pioneer Angus McMillan had named the river after an Avon in his native Scotland). Nonetheless, Stratford has embraced its Shakespearean connection with an annual 'Shakespeare on the River Festival' since 1989. Nearby is a park called Knob Reserve, which was formerly known as the 'Forest of Arden'!

The other Australian 'Stratford-upon-Avon' is in New South Wales, 9 miles south of Gloucester and 68 miles north of Newcastle. Again, it is on a River Avon and, like its English counterpart, has a Henley Street, Bridge Street and Wood Street, as well as a Shakespeare Street.

In Ontario, Canada, is another Stratford on an Avon River. First settled in 1832, the townsite and river were named after their English counterparts. Settlement was slow until the railway arrived in the early 1850s, then it was incorporated as a town in 1859 and as a city in 1886. Appropriately the swan has become the city's symbol, and each year twenty-four white swans are released into the river.

Stratford Ontario is well known as the home of the Stratford Festival, formerly the Stratford Shakespeare Festival, which features not only Shakespeare's plays but also a wide range of other productions. The festival began in 1953, and was opened by Alec Guinness reciting the first lines of the festival's first play. For the first four seasons the performances took place in a concrete amphitheatre covered by a giant canvas tent on the banks of the Avon. A new Festival Theatre was opened in 1957, with seating for an audience of more than 1,800. As well as Alec Guinness, actors such as Christopher Plummer, Maggie Smith and William Shatner have appeared there.

There are around a dozen Stratfords in the USA, and some are known to have been named after Stratford, England. In Connecticut in 1643 a growing town replaced its native American place name with Stratford to honour Shakespeare's birthplace. In Ohio a Stratford appeared in 1850, in Iowa in 1880, in New Jersey in the 1880s, and in Wisconsin in 1891, all named after the Warwickshire town.

On North Island, New Zealand, in 1877 the site for a new town was authorised on the banks of the Patea River. At first known as Stratford-upon-Patea, the supposed similarity of the Patea to the English Avon led to a renaming to plain Stratford; it was fashionable at the time to name towns after the birthplace of prominent Britons, and in Stratford sixty-seven streets were named after characters from twenty-seven of Shakespeare's plays. The town has a clock tower that plays the balcony scene from *Romeo and Juliet* three times a day – in words rather than bells!

'The Mechanics'
A MIDSUMMER'S NIGHT DREAM
SHAKESPEAREAN FESTIVAL 1960
Stratford, Canada

Bottom and his fellow 'mechanicals' are seen in this postcard view of a 1960 production of *A Midsummer Night's Dream* at the Shakespeare Festival in Stratford, Ontario, Canada. On the back the writer says, 'This festival centre is *so* like the original – even Avon and swans. But the theatrical performances are a little more naive. High quality, though.' (Commercial postcard, author's collection)

P

John Payton, the White Lion and New Town

The sixteenth-century White Lion Inn occupied several buildings in Henley Street. In 1753 it was demolished and rebuilt by its then landlord, John Payton, to become one of the largest inns on the Holyhead Road; indeed, it was considered the equal of some London eating establishments.

Payton was a Shakespeare enthusiast, and a friend of the Shakespearean editor George Alexander Steevens. In 1768, when Stratford's new Town Hall had just been completed, Steevens stayed at the White Lion. Payton felt that the new building would be enhanced by a statue of the Bard, and Steevens offered to persuade Shakespearean actor David Garrick (qv) to present one. This in turn led to Garrick's celebrated Shakespeare Jubilee (qv) of 1769. The remaining portions of the White Lion were listed by English Heritage in 1994.

As well as an influential figure in the promotion of Stratford and its famous son, Payton was also responsible for the town's expansion in the 1770s. The town had barely grown since the middle of the thirteenth century, but more substantial expansion began following several Acts allowing the enclosure of former common fields in the late eighteenth century, of which Payton was an enthusiastic promoter.

This is Payton Street in Stratford's New Town, named after publican and developer John Payton. It contains pleasant, albeit generally small and plain, Georgian buildings built between 1818 and 1826. On the right is a Baptist Chapel, distinguished by its Greek Doric porch.

He received the largest individual allotment, of 286 acres, in a 1775 enclosure. It was the first and largest new development beyond the existing borough limits on the north side of the town, where he laid out and developed land including John Street and Payton Street. When the canal arrived in 1816 it further enhanced the importance of this development, which was now marked on maps as the New Town. Payton sold the land for building in 1817, and residential development began the following year. Direct communication with the centre of the old town was made by the cutting of Union Street (qv) through to Bridge Street and Henley Street in 1830, while industrial development took place along the Birmingham Road.

John Profumo

John Profumo achieved notoriety through the celebrated 'Profumo affair' of 1963, but it is often overlooked that he was at the time the MP for Stratford-upon-Avon. Born in 1915 and educated at Harrow and Oxford, he was decorated for his distinguished service during the war, and while still serving he was elected MP for Kettering, Northamptonshire, in 1940. He was the youngest MP, and by the time of his death was the last surviving member of the 1940 House of Commons. That year he also succeeded to his Italian father's title as the 5th Baron Profumo.

Defeated by a Labour candidate at Kettering in 1945, in the General Election of 1950 he was elected to the safe Conservative seat of Stratford. In 1954 he married the actress Valerie Hobson and, highly respected, rose through the Conservative ranks to become Secretary of State for War in 1960. However, in July 1961 he met model Christine Keeler at a party, and they began a brief affair. Although it ended after only a few weeks, it transpired that Keeler had also had a relationship with Russian senior naval attaché Yevgeni Ivanov, so the affair became a matter of national security. For more than a year it was kept under wraps, but in March 1963 the rumours linking Profumo with Keeler surfaced in the House of Commons. Profumo admitted knowing Keeler, but that there had been no 'impropriety' involved. However, his position became increasing untenable, and in June he had to admit that he had lied to the House, and resigned. The scandal rocked the government, and is likely to have contributed to the fall from power of the Conservatives at the 1964 General Election.

Profumo maintained complete public silence about the affair for the rest of his life, moving from politics to become a charity fundraiser in London's East End, living on his inherited wealth. This redeemed his reputation somewhat, and he was awarded the CBE in 1975. He only seldom appeared in public, and in 2006 suffered a stroke, dying two days later at the age of ninety-one.

Meanwhile, in Stratford the by-election necessitated by his resignation was won by Conservative Angus Maude, father of former Conservative MP Francis Maude. Maude held the seat until 1983, then upon his retirement he became a life peer, taking the title Baron Maude of Stratford-upon-Avon in the County of Warwickshire. He died in 1993.

Q

Anthony Quayle

John Anthony Quayle, the distinguished actor and director, was born near Southport in 1913 and trained at RADA in London. In 1932 he joined the Old Vic, then during the Second World War he served with the Special Operations Executive as a liaison officer with the partisans in Albania, an experience that he apparently spoke little about in later years.

In 1948 he was appointed artistic director of the Shakespeare Memorial Theatre, where he laid the foundations for the creation of the Royal Shakespeare Company under his successor Peter Hall. Quayle used his many theatrical connections to get star names to appear at Stratford, among them Laurence Olivier, Vivien Leigh, Ralph Richardson, John Gielgud and Michael Redgrave. His tenure was also marked by sumptuous settings and costumes, which all served to raise the profile of the theatre. As well as directing, he played Falstaff, Othello, Benedick, Henry VIII and Aaron in *Titus Andronicus*, the latter opposite Laurence Olivier; he also appeared in contemporary plays.

By this time he also had a successful film career, having made his debut in an uncredited role in the 1938 Leslie Howard/Wendy Hiller production of *Pygmalion*. He went on to star in such films as *Ice Cold in Alex*, *The Guns of Navarone* and *Lawrence of Arabia*, and was Oscar-nominated for his role as Cardinal Wolsey in the 1969 film *Anne of a Thousand Days*.

His tenure at Stratford lasted until 1956, when he was succeeded by Glen Byam Shaw and, in 1960, Peter Hall.

In 1984 Quayle founded the Compass Theatre Company, playing the title role in *King Lear* in one of its productions. Having been made a CBE in 1952, he was knighted in 1985 for services to the theatre. He died in London in 1989.

Fellow actor Robert Stephens said of him, 'A really lovely man, untouched by any of the bitterness or deviousness, which sometimes characterises people who have run great companies.'

Thomas and Judith Quiney, née Shakespeare

Thomas Quiney was a vintner in Stratford, and in 1616 he married William Shakespeare's surviving twin daughter, Judith, born in 1585. The wedding took place in the pre-Lent season of Shrovetide, when marriages were prohibited, so it required a special licence from the Bishop of Worcester, which they failed to secure. As a result Quiney was summoned to appear before the Consistory court in Worcester, failed to appear by the required date, and was therefore excommunicated.

To compound matters, it transpired after the wedding that another woman, Margaret Wheeler, was expecting Quiney's child; however, both she and the child died in childbirth. Quiney was forced to admit to his 'incontinence' with Margaret and was sentenced to public penance in front of the church congregation, but in the end suffered no more than a 5 shilling fine, to be given to the poor of the parish.

Judith and Thomas Quiney had three children, but none survived to marry. The curiously but aptly named Shakespeare Quiney lived only six months, Richard died in 1639 aged twenty-one, and Thomas in the same year, aged nineteen, both possibly from plague – tragically they were buried within nine days of each other. The loss of any heirs caused legal wranglings regarding William Shakespeare's will, which was altered hastily during the last months of his life. Possibly for reasons of his earlier behaviour, Thomas was omitted; initially there had been an inheritance to 'my son in law', but this was later struck out and Judith's name substituted. Her inheritance was also subject to provisions to safeguard it from her husband; the money she received was explicitly denied to him unless he bestowed on her land of equal value. Shakespeare's elder daughter, Susanna, and her husband, Dr John Hall, were left

This building on the corner of Bridge Street and High Street, once known as 'The Cage', was where Shakespeare's son-in-law Thomas Quiney ran his wine merchant's business. The building has since been refronted on at least three occasions.

This plaque on the corner of the building records the fact that it was restored in 1923 by stationer W. H. Smith, which occupied it between 1906 and 1922.

the bulk of the estate, Susanna having apparently been her father's favourite. The contrast between Judith's marriage to the apparently disreputable Quiney (despite being Chamberlain to the town's governing council in the early 1620s) and Susanna's to respected doctor John Hall must have been all too evident to the family, and the loss of her children must have also been a heavy burden to bear.

From 1611 Thomas had a lease on a tavern called 'Atwood's' in High Street, and in 1616 moved his vintner's shop to the upper half of a house at the corner of High Street and Bridge Street, known as 'The Cage'. The building is still in existence, though no longer a tavern. In 1633, to protect the interests of Judith and her children, the lease was transferred to John Hall and Thomas Nash, Shakespeare relations by marriage.

Judith Quiney, who seems to have received no education and was likely illiterate, died at the grand age of 77 in 1662, and with her died any possibility of direct descendents of William Shakespeare; she had outlived her last surviving child by twenty-three years. She is buried in Holy Trinity churchyard, but exactly where is not known. Thomas is thought to have died at around the same time, or he may have left Stratford.

As Shakespeare blogger Sylvia Morris points out, the fact that no one appears to have spoken to her about her famous father 'is without doubt one of the biggest lost opportunities in the history of Shakespeare biography. Judith was 31 when her father died and even at the great age of 77 would surely have had memories she could have shared. It's just another of the factors that makes Judith Shakespeare's story so intriguing.'

As a footnote, Thomas's father Richard Quiney was the writer of the only known surviving letter written to Shakespeare, when in 1598 he wrote to his 'Lovinge good ffrend & contrymann' asking for a loan in support of his quest to negotiate a more favourable Charter for Stratford.

The Racecourse

The first officially recorded horse race in Stratford took place in 1755 on Shottery Meadow, which in 1769 also hosted the Garrick Jubilee Cup race during the actor's Jubilee celebrations (qv). However, it was not until 1836 that a National Hunt race was once again officially run. Racing became increasingly popular, and the Stratford course hosted the Shakespeare Cup, the Warwickshire Hunt, the Diamond Jubilee Cup and the Warwickshire Hunt Coronation Cup.

In 1933 a railway halt known as Stratford-on-Avon Racecourse Platform was opened on the adjacent Great Western Railway's Birmingham–Cheltenham main line. Intended purely for racegoers and only a mile south of the town's main station, just basic facilities were provided, with two simple platforms constructed from rail and sleepers. The station nameboard had a separate board below it informing racegoers of the date of the next meeting. In due course increased car ownership saw passenger numbers fall, and the station closed in 1968; the line itself closed in 1976. The site of the station is now part of the Stratford-upon-Avon 'greenway'.

In 1968 the extended racecourse played host to the 200th anniversary Garrick Jubilee Cup Festival, a three-day event. A 2-mile hurdling event was introduced for the occasion, the Garrick Jubilee Challenge Cup, which is still run today, one of the nineteen current fixtures between March and November that enjoy an excellent reputation for good prize money, with many top trainers and jockeys attending. One of the best of the country's smaller courses, Stratford is family friendly and allows people to picnic in the centre.

Railways

Stratford-upon-Avon has had three railway stations: one has survived throughout, one has gone and, more recently, another added.

The first railway to reach the town was the Oxford, Worcester & Wolverhampton, which opened a line from Honeybourne in the south in 1859. Then the Stratford Railway's branch from Hatton arrived from the north the following year, and the two terminal stations were combined into a through station in 1861; the latter's facility became the town's goods station. Both lines subsequently became part of the Great Western Railway.

The opening of the GWR's route from Birmingham to Cheltenham in 1908, incorporating the line through Stratford, gave the town main-line status, and the station was expanded, with a third through platform on the up (west) side to cater for local services from Honeybourne and Hatton. Only the original platform buildings on the east side survived the alterations. The GWR footbridge is dated 1891. In 1968 through services to Gloucester were withdrawn, and passenger services south of Stratford ceased altogether on 5 May 1969. Freight traffic continued until 1976, when a derailment provided a reason to close the line entirely, leaving Stratford as a terminus of the lines from Birmingham and Hatton. Presently trains run from Stratford to or through Birmingham to Stourbridge, and to Leamington and Warwick, with some continuing to London Marylebone. On summer Saturdays there is also a steam-hauled service to and from Birmingham, which is naturally very popular with tourists.

The next line to arrive was that of the company that became the Stratford-upon-Avon & Midland Junction Railway (SMJR) – dubbed the 'Slow Miserable and Dirty' – an amalgam of several smaller but nonetheless grandly titled and impecunious companies that made up a route from Broom Junction in the west to Ravenstone Wood Junction on the Midland Railway south of Northampton in the east. It arrived in 1873 in a town that already offered rail passengers GWR services to Birmingham, London, the South West and Wales. The SMJR's station was known as Old Town, and was some distance from the centre. Nonetheless, for a few years at the beginning of the twentieth century the Great Central Railway ran a through coach from London Marylebone via Woodford Halse – this was in fact the shortest route from London to Stratford, at 89½ miles, and was promoted as 'The Shakespeare Route'. The London & North Western Railway also exploited its connection with the line at Blisworth to run specials to Stratford in the early years.

When the SMJR was formally incorporated in 1908, an engine shed and carriage shed were provided and the station boasted the company's only refreshment rooms. In 1923 the line became part of the London Midland & Scottish Railway, then all Stratford's railways became part of British Railways in 1948, the year after the

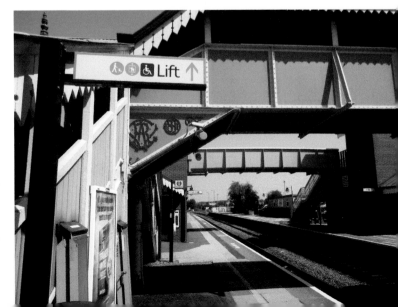

The modern footbridge at Stratford-upon-Avon, complete with lifts, is framed by its 1891-dated predecessor, which also carries the monogram of the Great Western Railway. This is the view looking north.

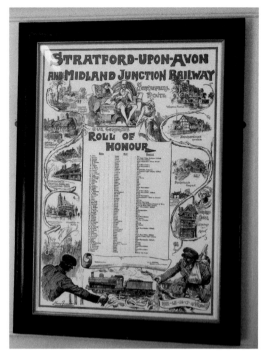

Left: Framed in the station's booking office is the SMJR's First World War Roll of Honour, from the long-vanished Old Town station. It is surrounded by wonderful sketches of Stratford landmarks by renowned artist and caricaturist Harry Furniss (1854–1925). Note the 'Shakespeare Route' advertising slogan.

Below: The timetable for the through carriage from London Marylebone to Stratford via Woodford & Hinton (later Woodford Halse), from the Great Central Railway timetable for the late summer of 1903.

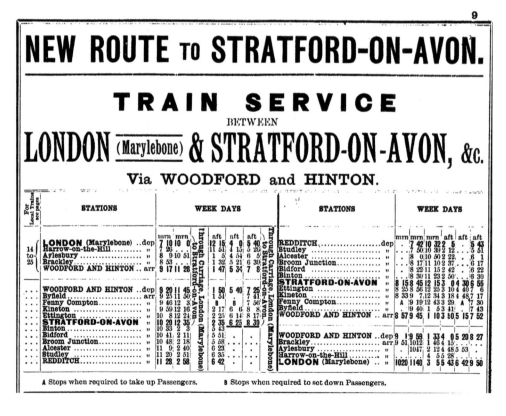

9

NEW ROUTE to STRATFORD-ON-AVON.

TRAIN SERVICE

BETWEEN

LONDON (Marylebone) & STRATFORD-ON-AVON, &c.

Via WOODFORD and HINTON.

A Stops when required to take up Passengers. B Stops when required to set down Passengers.

Stratford-Broom service was withdrawn. In 1952 all passenger services ceased at Old Town, although the more successful goods traffic soldiered on until 1965.

Between 1960 and 1965 a new chord line was built to link the former SMJR and GWR lines and facilitate through iron ore traffic from the Midlands to South Wales.

The most recent addition to Stratford's railway map is Stratford Parkway, built on the northern outskirts with 'park and ride' facilities. It has two footbridge-linked platforms, and opened in 2013.

Rother Market and the 'American Fountain'

'Rother' is an Old English word for 'ox' or 'cattle' (as in Rotherhithe in London's docklands), and Rother Market, at the top of Rother Street, is where the town's cattle market used to be held; it is now the site of the weekly Charter Market held on Fridays.

Stratford-upon-Avon was particularly well placed to serve as a market centre, being on the important crossing of the River Avon where several routes from the

Below left: The 'American Fountain' in Rother Market.

Below right: The fountain's water troughs are now filled with flowers. Note the American and British eagle and lion above the plaque that bears a quotation from Washington Irving.

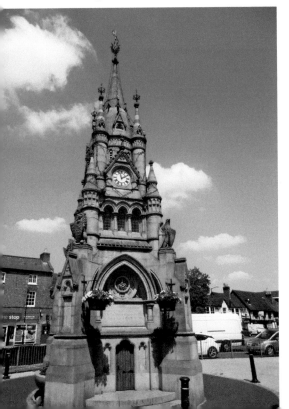

surrounding countryside converged. A special charter was granted in 1196 by King Richard I allowing the town to hold a weekly market. Following the suppression of the Guild of the Holy Cross, King Edward VI granted a charter of incorporation to the town in 1553 giving the inhabitants the right to hold, and collect tolls from, a weekly Thursday market and two annual fairs. In 1819 King George III authorised a change of day to Friday, to avoid competition with markets in other nearby towns.

Prominent in Rother Market is the Shakespeare Memorial Fountain (also known as the American Fountain). It is a Grade II*-listed clock tower built in the Victorian Gothic style and gifted to the town by American printer, bookseller, publisher, newspaper proprietor and philanthropist George W. Childs of Philadelphia to commemorate William Shakespeare and to celebrate Queen Victoria's 1887 Diamond Jubilee. It incorporates horse and cattle troughs above smaller ones for dogs and sheep (now filled with flowers) and a drinking fountain, and was made in 1886–87 to a design by artist and architect Jethro Anstice Cossins of Birmingham (1830–1917). Its listing entry describes it as 'a particularly important example of a Victorian public monument ... in an individual and expressive Gothic style, displaying particularly high quality detailing and stone carvings'. The latter were by Robert Bridgeman.

Childs had already donated a window to Westminster Abbey commemorating the poets George Herbert and William Cowper, and wanted to donate a window dedicated to Shakespeare; however, following discussions it was decided that the memorial should take its present form and be erected in the market square on Rother Street. The town's Corporation would arrange the supply of water and a light at night.

The unveiling ceremony was performed by the eminent Shakespearean actor Henry Irving (qv) in October 1887, who read out a specially commissioned poem by Oliver Wendell Holmes, and praised Mr Childs's generosity. A telegram from Queen Victoria was also read out; she was said to be 'pleased to hear of the handsome gift from Mr Childs to Stratford-upon-Avon'. Following this was a lunch in the Town Hall, where toasts were given to Queen Victoria, Shakespeare, Mr Childs and Mr Irving.

The three-stage square-plan tower is approximately 18 metres high. The lower stage has buttresses capped by the British Lion and the American Eagle holding shields with the Royal arms and the Stars and Stripes, respectively. The top stage has clock faces and finials representing 'Puck', 'Mustard-Seed', 'Pea-blossom' and 'Cobweb', fairy characters from *A Midsummer Night's Dream*. There are also several inscriptions and quotations.

Royal Label Factory

The Royal Label Factory was established in Stratford in 1874 to make labels for Queen Victoria's gardens at Sandringham, receiving a Royal Warrant for the work in 1876. By 1896 the firm advertised itself as John Smith, metal label manufacturer, of Rother Street; by the early twentieth century it was a 'manufacturer of imperishable metallic and garden labels to the Imperial Department of Agriculture'. By the 1930s

Right: A nostalgic collection of road signs from the past can be enjoyed in this view of a Royal Label Factory trade stand in the early 1950s. (Courtesy of Leander Architectural)

Below: In 1953 the firm was trading as F. A. & F. Ball Ltd, and this fine collection of signs is evidently destined for Kent. (Courtesy of Leander Architectural)

the firm was supplying up to half of the signposts and fingerposts for county and town councils across the UK. At the height of the cast road sign boom in the early 1950s, the RLF employed 100 people. In around 1963 it moved to Chipping Norton, where it continued to supply traffic signs and street furniture, especially to its biggest customer, Oxfordshire County Council.

In 1998 the RLF became part of Leander Architectural of Buxton, a company that makes blue plaques for civic trusts and societies throughout the UK, signs of all kinds for heritage agencies such as the National Trust, Historic Scotland and Cadw-Welsh Monuments, and military memorials and items such as glazed canopies and arcades,

bandstands and shelters. The moulding and casting techniques have changed little over the years, but are now supplemented by modern techniques such as computer graphics and laser cutting and etching, and the foundry now uses electric furnaces.

In 2007 a collection of old plant labels was discovered at Westonbirt Arboretum in Gloucestershire. They were of all shapes and sizes, and some were marked 'J. Smith Royal Label Factory, Stratford on Avon'.

Royal Shakespeare Theatre

Stratford's first theatre dedicated to Shakespeare was the temporary, 1,000-seat, wooden octagonal structure erected on the Bankcroft for Garrick's Jubilee event of 1769 (qv). In 1827 the relatively modest Royal Shakespeare Rooms were opened in Chapel Lane, closing in the 1860s. Then to mark the 300th anniversary of the playwright's birth in 1864 there was a national campaign to erect a permanent monument, and local brewer Charles Edward Flower (qv) bought 2 acres of vacant land in the Bankcroft; the Shakespeare Memorial Association was established in 1875. The Shakespeare Memorial Theatre, built in 1877–79 and 'lavishly Gothic' (Pevsner), consisted of a 600-seat horseshoe-shaped auditorium, a tall water tower and, across a bridge, a separate library and museum building added in 1881. The open ground around the theatre was landscaped during the 1880s. Tragically, in March 1926 a

This *c.* 1906 postcard painting shows the original Memorial Theatre in all its Gothic glory. Note the Gower Memorial in its original position beside the river.

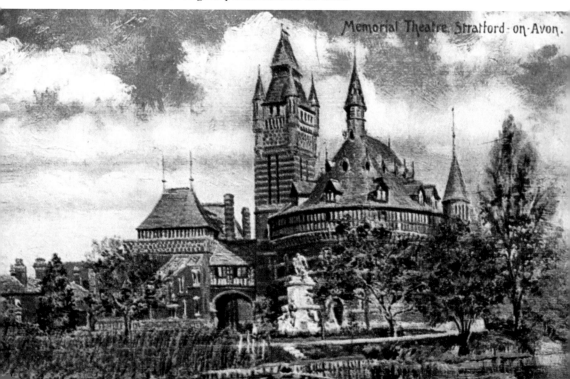

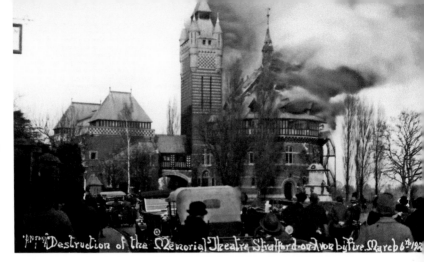

On 6 March 1926 the theatre was badly damaged by fire, as shown in this dramatic postcard view. (Commercial postcard, author's collection)

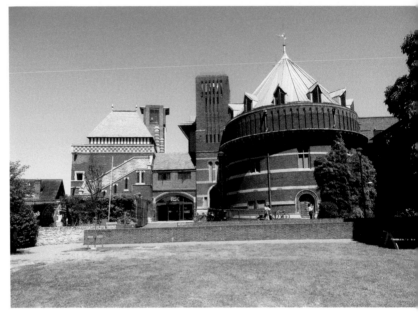

This is the surviving portion of the old theatre, in use today as the Swan Theatre.

disastrous fire largely destroyed the theatre, although the separate building and its bridge were relatively undamaged and still form part of today's complex.

To replace the theatre an open architectural competition was organised in 1928. It was won by Elisabeth Scott, a cousin of noted architect Sir Giles Scott; she was only twenty-nine, and the theatre was the first large public building in Britain to be designed by a woman. It was modern and functional, but criticism of the auditorium and backstage facilities, including the elongated shape of the auditorium and problems with sight lines, led to alterations soon after completion, with further developments taking place throughout the following decades.

The new theatre opened in 1932, and incorporated distinctive art deco features. The shell of the old one was initially left as a ruin, then converted by Scott in 1933 to become a conference centre; however, in 1984–86 it was further converted to become

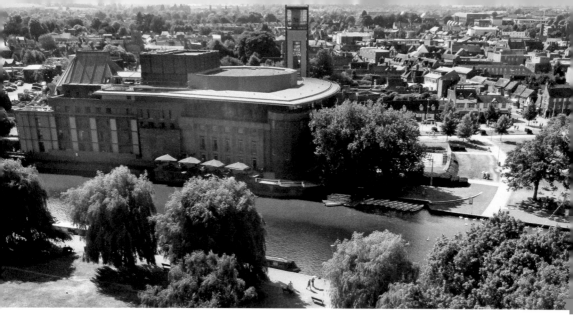

Above: This aerial view across the river from Stratford's 'Big Wheel' shows how the two theatres are joined back to back, the Swan on the left and main house on the right.

Left: The façade of the Royal Shakespeare Theatre is changed somewhat from the 1933 original, particularly the upper portion and the addition of the viewing tower; further work is under way in front of it. In the foreground, incorporating a bench, is the 2016 sculpture *Young Will* by Lawrence Holofcener.

a second auditorium, known as the Swan Theatre, the two theatres' stages being back to back. The main house was renamed the Royal Shakespeare Theatre in 1961.

In the 1990s it was suggested that the theatre be completely demolished, but Lottery funding and an intervention by English Heritage led to a compromise, and after a great deal of discussion the £112.8 million 'Transformation Project' produced a radically new thrust-stage layout within Scott's structure, enabling actors and audience to be brought closer together, in the manner of theatres in Shakespeare's day. The most historically and architecturally significant features were retained, and between 2005 and 2011 the building was restructured with new public and office areas, improved access, and a distinctive 36-metre (118-foot) viewing tower offering panoramic views across the town. Performances were transferred to the temporary Courtyard Theatre, which later became The Other Place (qv). The building is now Grade II* listed.

S

William Shakespeare

Considering the cult surrounding England's greatest dramatist, especially of course in his native Stratford-upon-Avon, the facts about William Shakespeare's life are intriguingly sparse – indeed, it could be argued that this lack of knowledge has helped to fuel our unending fascination with him over the last four centuries.

His birth date is unknown, but is traditionally accepted to be on 23 April 1564, St George's Day (a happy coincidence). What is known is that he was baptised on the 26th, the son of successful glove-maker John Shakespeare and his wife Mary (née Arden – qv). No attendance records for the King's New School, established in 1553, survive, but again it is generally accepted that the young Shakespeare was educated from the age of around seven at what became the Grammar School. It was not far from his home, and probable birthplace, in Henley Street. John and Mary had eight children – four daughters and four sons. Joan was the only daughter to survive childhood, while William was the eldest of the four sons.

William probably left school at the age of fourteen or fifteen, with a well-rounded education, judging by his plays. When he was eighteen, in 1582, he married twenty-six-year-old Anne Hathaway (qv), who was already pregnant. Their first

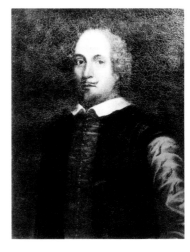

This portrait of William Shakespeare belonged to the family of Stratford Town Clerk William Oakes Hunt for many years, and was later presented to be displayed in the Birthplace. Whether it is a good likeness is impossible to say...

daughter, Susanna, was baptised in May 1583, and twins Hamnet and Judith followed almost two years later.

Stratford was often visited by travelling players, and it may have been one of these that roused the young William's interest in the stage. However, the period 1585 to 1592 is often referred to as his 'lost years', and the reasons for his move to London and the beginnings of his writing career have been the subject of much speculation. Nonetheless, by the latter date he was established in the London theatrical scene, with his early plays produced – yet once more there are few solid historical leads to follow.

Throughout his career he seems to have divided his time between London and Stratford. In 1596 he was living in Bishopsgate, then in 1599 Southwark, south of the Thames, near the Globe Theatre. By 1604 he was north of the river again, near St Paul's. Meanwhile, in 1597, now a man of substantial wealth, he had bought New Place in Stratford (qv), one of the town's largest properties, and inherited the house in Henley Street when his father died in 1601.

There is a tradition that Shakespeare retired to Stratford 'some years before his death', but he was still acting in London in 1608. The following year plague repeatedly closed the London theatres, but records show that Shakespeare continued to visit the capital between 1611 and 1614. He appears to have stopped writing in 1613, and died in Stratford on 23 April 1616 at the age of just fifty-two, less than a month after he revised and signed his will, declaring himself 'in perfect health'. We don't know the cause of his death, although it seems to have been sudden; one rumour puts it down to a fever following a drinking bout with fellow writers Michael Drayton and Ben Jonson.

There are no written descriptions of Shakespeare's appearance, and he apparently never commissioned a portrait, but the picture by Flemish engraver Martin Droeshout that illustrated the 1623 folio edition of his works (which contained thirty-six plays and sold for £1) was claimed by Jonson to be a good likeness.

Shrieve's House, Sheep Street

Considered to be the oldest house in Stratford still in domestic occupancy, this timber-framed house, with its cobbled carriageway and large sixteenth-century barn behind, is Grade II* listed. It became known as Shrieve's House in the twentieth century after William Shrieve, who was an archer to Henry VIII and the first recorded tenant of the property, in 1542 – although the foundations date back to 1196. It belonged to the Guild of the Holy Cross, then later the Corporation. It was once an inn owned by William Rogers, a tavern-keeper upon whom, it is traditionally thought, Shakespeare's Falstaff was modelled. It was home to the first mayor of Stratford, John Woolmer, and Edward Gibbs, who was responsible for renovating the 'Swan and Maidenhead', Shakespeare's birthplace, in Henley Street in 1858. It is also reputed to be one of the most haunted buildings in England. Its listing record describes it as 'a good example of a late 16th- or early 17th-century yeoman's house retaining its range of outbuildings'.

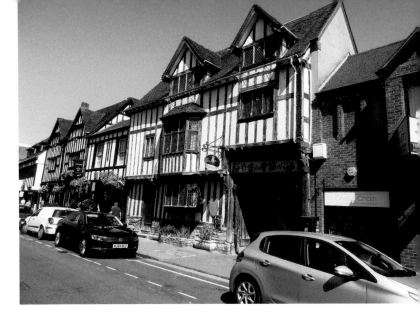

Shrieve's House is reputed to be the oldest house in Stratford still in domestic occupancy. Through the arch nearer the camera is the cobbled passageway leading to the Tudor World museum.

The front of the house on Sheep Street dates from 1470, but the remainder of the house was heavily rebuilt and enlarged after fires tore through Stratford in 1595 and again in 1614. Parliamentary soldiers were billeted here for the Battle of Edgehill in 1642 during the Civil War. It was restored in 1908, 1947 and again in 1979.

Behind Shrieve's House is the award-winning, privately run, family-friendly Tudor World, a museum that covers all aspects of Tudor life. It includes recreations of daily life of the period through multi-sensory experiences involving sights, smells, sounds and interactive displays.

'Stratford Blue'

There were horse-drawn buses running between Leamington and Warwick from the 1880s, replaced by an electric tramway in 1905. At around this time the Leamington Motor Omnibus Co. Ltd was formed, and a single-deck bus able to carry luggage on the roof began running twice a day between Kenilworth and Stratford-upon-Avon. When the First World War started, the company's owners decided to discontinue the bus service in the Leamington area, leaving the tramway system without competition until a new company was formed in April 1927, Stratford-upon-Avon Motor Services, which ran between Stratford and Leamington using a blue fourteen-seater Chevrolet bus.

In 1929 the company was acquired by the Leamington and Warwick concern, but remained as a separate operation until May 1931. It was then registered as a limited company under the name of Stratford-upon-Avon Blue Motors Limited, operating in its own right.

In 1935 control passed to the British Electric Traction Group (BET), when the company was purchased by the Birmingham & Midland Motor Omnibus Co. Ltd (BMMO), known locally as Midland Red, although Stratford Blue continued to operate as a subsidiary for the next thirty-five years.

Stratford Blue Leyland PD2/12 double-decker No. 20 of 1956 waits for departure outside the Mulberry Tree Restaurant at the bottom of Bridge Street in April 1964. The town is celebrating the 400th anniversary of Shakespeare's birth, hence the flags along the centre of the road. Hawley's was a Birmingham-based bakery from 1896 until sold in the 1970s, and the bus was withdrawn from service in 1971. (Martin Llewellyn/Omnicolour)

STRATFORD-UPON-AVON
BLUE MOTOR SERVICES
Regular daily services throughout Shakespeare's country

Full time tables posted on application

Enquiry Office: **28, Wood Street,**

Telephone 307. **Stratford-upon-Avon**

An advert from around 1930.

An increase in wartime passenger traffic led to the first double-decker being purchased in 1940, albeit second-hand. In 1947 new bus orders were put under the control of the Stratford Blue management, and eighteen new buses were delivered the following year. In 1952 BMMO invested further in the company, and various smaller local concerns were acquired over the years.

In 1969 the BET Group, which held the controlling interest in BMMO, sold its passenger transport interests to the state-run National Bus Co., which decided to absorb the Stratford Blue Co. into BMMO operations; consequently on the first day of

1971 the latter company took over all Stratford Blue's vehicles, around 40 buses, and its operations, not only the town services but also the country routes to as far afield as Birmingham, Cheltenham and Oxford. As a result the familiar blue livery was lost to BMMO's all-over red. The Stratford Blue operating name was retained by BMMO until 1977, when the company was finally dissolved.

But that was not quite the end of the Stratford Blue story. In 2018 a double-decker bus belonging to Stagecoach Midlands, Midland Red's successor, was painted in the familiar blue livery to run round the town's street once more. Stagecoach Midlands' managing director said, 'We look forward to seeing it in service on all our routes radiating from Stratford-upon-Avon and hope that it evokes many happy memories for local people, as well as encouraging an interest in transport in younger generations.'

Stratford-upon-Avon Canal and Basin

The canal was promoted by an Act of 1793, from a junction with the Worcester & Birmingham Canal at Kings Norton, south of Birmingham, to Stratford, but lack of money prevented its completion through to Stratford until 1816. The previous year the canal company had obtained a further Act allowing it to connect with the River Avon. Its main traffic was coal; some continued its journey from Stratford down the Avon to Evesham, while some went across the river and on by rail on the Stratford & Moreton Tramway (qv), which had opened in 1828.

The canal was moderately successful, then in 1856 the Oxford, Worcester & Wolverhampton Railway bought both it and the tramway. The OW&WR became part of the Great Western Railway in 1863, which inherited the legal obligation to keep the canal open. However, traffic gradually decreased as the railway took over most of the long-distance loads.

By the late 1930s the southern section was derelict, while the northern part was still open, but virtually unused. Protesters, including the naturalist Peter Scott, insisted that the statutory right of navigation be maintained, but by the 1950s the southern section was unnavigable by canal boats, with several locks inoperable.

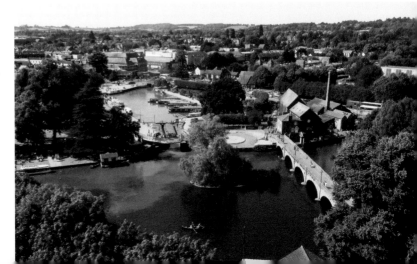

This aerial view from the 'Big Wheel' shows the basin of the Stratford-upon-Avon Canal and the lock giving access to the Avon centre left, and the Tramway Bridge and Cox's Yard on the right.

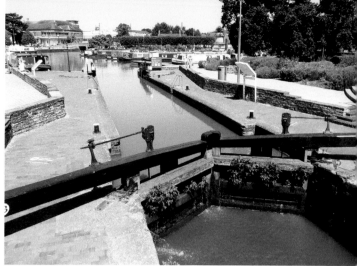

Above left: A bustling marina now occupies the canal basin.

Above right: This lock allows boats to pass to or between the canal and the river.

Left: These plaques adjacent to the first lock down the River Avon commemorate David Hutchings MBE RIBA, who led the restoration of the canal and the Upper Avon in 1964 and 1974, and the opening of the Upper Avon Navigation by HM The Queen Mother on 1 June 1974.

When Warwickshire County Council announced that it was closing the canal by lowering a bridge at Wilmcote, there was further public outcry, and in 1959 closure was averted. Meanwhile the Stratford-upon-Avon Canal Society had been formed in 1956, with the main aim of securing the future of the 'Southern Stratford' from Lapworth to the town. In 1960 the canal was leased from the British Transport Commission by the National Trust, and subsequent restoration by volunteers is said to have cost less than half of the estimated cost of filling it in. Once again fully navigable, the canal was reopened by HM The Queen Mother in 1964, the restoration representing a turning point for Britain's waterways. In 1988 the Trust transferred it back to the British Waterways Board and, together with the 'Northern Stratford', it now forms part of the Avon Cruising Ring, a circular route that, clockwise, takes in the Stratford Canal, the rivers Avon and Severn, and the Worcester & Birmingham Canal.

Stratford's canal basin is now a bustling area amidst the attractive Bancroft Gardens, with unusual permanently moored boat-based businesses selling a variety of food and snacks. It is also a base for a variety of sightseeing boat tours.

T

Town Hall

The first Town Hall was built in 1633, but was later extensively damaged by a gunpowder explosion during the Civil War when it was being used as a munitions store by the Parliamentary forces. Repaired in 1661, it was the venue for the first recorded performance of one of Shakespeare's plays in his home town when a touring company staged *Othello* in 1746 in aid of repairs to the author's monument in Holy Trinity Church. The building later fell into disrepair and had to be demolished. It was replaced on the same site by the present building in Cotswold stone, which dates from 1767 to 1768 and was extensively altered in 1863–64, including the filling in of the arches of what had originally been an open market space beneath, to create extra rooms. From 1843 it was used for Corporation meetings and is now used by Stratford Town Council. In 1946 a fire, caused by a discarded cigarette, gutted the ballroom, and a Gainsborough portrait of David Garrick standing beside a bust of Shakespeare was destroyed.

On the outside can be seen the remains of the painted words 'GOD SAVE THE KING', as well as the borough coat of arms and the date 1767. The Town Hall was opened by the actor David Garrick in September 1769, and his involvement led him to organise that year's Shakespeare Jubilee (qv); he also presented the lead statue in

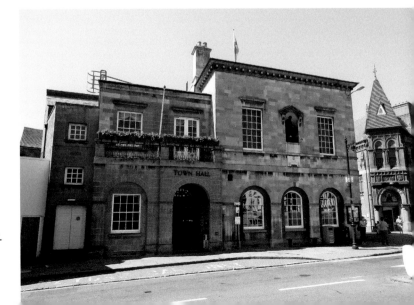

The ground-floor arches of the Town Hall were open and used as a market space until the 1860s. The Old Bank can be glimpsed on the right.

This close-up of the niche on the Chapel Street side shows the 1769 lead statue of Shakespeare by John Cheere, a copy of the 1740 statue on the playwright's Westminster Abbey memorial, and below it a stone commemorating the Queen's Silver Jubilee in 1977.

a first-floor niche. The Jubilee culminated in a ball at the Town Hall, and apparently the highlight of the evening was the dancing of Garrick's wife! The building was later used by the Shakespeare Club, founded at the Falcon Inn in 1824, for its annual dinner until it moved to the new Memorial Theatre in 1879.

Today the Town Hall is not regularly open to the public, but its rooms are used for a variety of events. Grade II* listed, it is described in its listing entry as 'a dignified building in an important position'.

The Tramway Bridge and Tramway House

The Stratford & Moreton Tramway was authorised in 1821 and opened in 1826. It was thus Warwickshire's first railway, predating the Grand Junction and London & Birmingham lines further to the east by some twelve years. It stretched 16 miles from the Stratford-upon-Avon Canal basin (qv) to Moreton-in-Marsh, with a later 1836 branch to Shipston-on-Stour. Its promoter, William James, envisaged it as part of an ambitious scheme to link the Midlands with London via canal to Stratford, tramway to Oxford, then down the Thames to the capital. Its horse-drawn trains carried Black Country coal southbound, while northbound came limestone and agricultural produce; the wagons were owned by licensed traders, who could also pay for a further licence to carry passengers.

In 1856 the Oxford, Worcester & Wolverhampton Railway, which had arrived in Moreton, was given powers to lease the tramway. In 1859 the southern section as far as Shipston was upgraded; however, the main railway line to Stratford had opened that year, revenues remained poor and the tramway went bankrupt in 1868, and was taken over by

the OW&WR's successor, the Great Western Railway. The GWR obtained powers in 1884 to work the line to Shipston by steam power, and the upgraded route was officially reopened in 1889 with a service of four trains per day in each direction. These were withdrawn in 1929 when buses took over, but occasional freight traffic survived until 1960.

Meanwhile the section from Shipston to Stratford continued to use horses until it fell into disuse in the 1880s. The tracks were eventually lifted in 1918 in aid of the war effort, and the line was formally abandoned in 1926 after all but a month of a century of operation.

To reach the canal basin in Stratford the brick-built Tramway Bridge was constructed across the Avon in 1823, which today, Grade II listed, is still in use as a footbridge. At the west end of the bridge is the tramway toll house of 1825–26, and details of the line's history, together with a preserved horse-drawn wagon, can be found nearby.

A preserved wagon on a length of track and an information board about the Tramway can be found outside Cox's Yard.

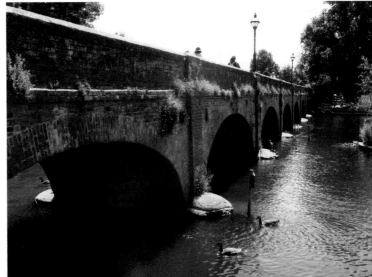

The nine-arch Tramway Bridge of 1823 brought the Tramway across the Avon to the canal basin.

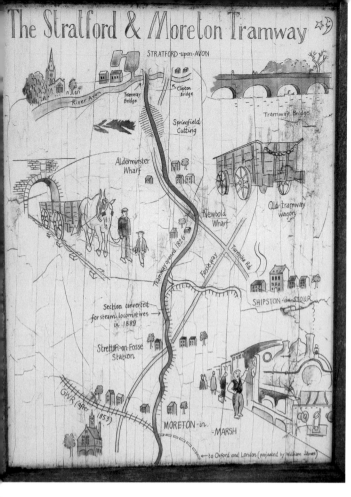

The Stratford & Moreton Tramway

Left: This useful map on the fence beside the wagon shows the route of the Tramway from Stratford to Moreton.

Below left: Now a pedestrian bridge, the surface of the Tramway Bridge is cleverly illuminated at night to simulate the original tracks.

Below right: The course of the Tramway south from Stratford is now a pleasant and leafy walkway, and here crosses a well-preserved bridge.

U

Union Street

The development of what became known as New Town was begun by John Payton (qv) of the White Lion Inn, who received 286 acres of land to the north of the town as a result of a 1775 enclosure. The Stratford-upon-Avon Canal arrived in 1816, which further enhanced the importance of the ensuing development. Payton sold the land for building in 1817, and residential development began the following year, including the self-named John Street and Payton Street. In around 1830, to connect the new development with the Old Town, where Henley Street and Wood Street met Bridge Street, a new road was cut through, aptly named Union Street.

The first buildings appeared in around 1833, and prominent in Union Street is a long range of Italianate warehouses built in 1861, and extended, with its distinctive tower, in 1868. At the north end of Union Street is Guild Street, which has some fine 1837 terraces, three storeys with chequer brickwork. There is also the Gothic Newland Almshouses of 1857. As Pevsner points out, the plots here were big enough to accommodate 'Leamington-style villas', although the side streets have mostly smaller late Georgian houses.

Today busy Union Street contains the usual mix of town centre facilities, from charity shops to banks, and hairdressers to estate agents.

In this view looking down Union Street towards the New Town, the long range of Italianate warehouse buildings on the left date from 1861. Built for Ashwin & Co., they were extended, including the tower, in 1868.

Victoria Spa, Bishopton

The mineral spring at Bishopton, an outlying hamlet of Stratford, was first brought to the attention of the public by Dr Charles Perry in 1744, although it had been known about for centuries. It had become renowned for its curative properties by 1800, and in 1834 a syndicate of four Stratford businessmen bought the site and began to develop it, including the erection of a hotel. The waters were favourably analysed, and the new spa was opened by the seventeen-year-old future Queen Victoria in May 1837, just six weeks before she ascended the throne. Her Majesty spent a night in the hotel, today a recently refurbished guest house, the Victoria Spa Lodge, and the Royal Arms can be seen in the gables as well as the fireplaces of bedrooms on the first floor. Indeed, the Victoria Spa Hotel is believed to be the first establishment to have been named after the future Queen. Adjacent were the Spa Lodge and Pump House, and it backs onto the Stratford Canal.

There were plans to further develop the area to the south and east, with roads laid out. A chapel was built in The Avenue in 1842–43, but demolished in 1969, though its graveyard remains. Several stylish villas were erected in the 1840s, but the enterprise

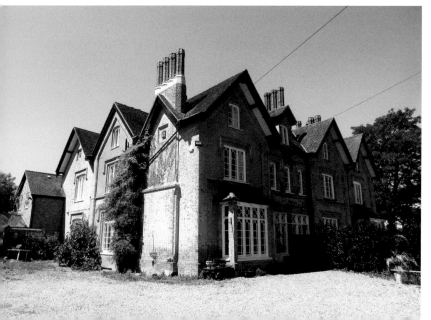

The elegant Victoria Spa Lodge, dating from around 1837, is currently being refurbished as a period guest house.

Right: The soon-to-be crowned Queen Victoria opened the spa, and the royal arms can be seen in the building's gables.

Below left and right: One the building's famous later occupants was the cartoonist Bruce Bairnsfather, creator of the 'Old Bill'. One of his best-loved books was *Fragments from France*, with much dry and sombre humour from the First World War.

failed to prosper, and by the mid-1850s most of the area had been sold off and returned to agriculture. The spa buildings were refurbished and reopened in 1868, but could find no buyer when offered for sale, and the venture failed soon afterwards.

The hotel was later the home of cartoonist Bruce Bairnsfather (1887–1959), famous as the creator of the First World War soldier 'Old Bill' and author of *Fragments from France*. Another famous resident was Sir Barry Jackson, founder of the Birmingham Repertory Theatre.

The Welcombe Hotel

Although it sounds like an ideal name for a hotel, Welcombe, a settlement on the north-east outskirts of Stratford in a fold of the Welcombe Hills, dates back to the twelfth century. At one point it passed to the Clopton family. Between 1774 and the 1830s it was owned by John Lloyd of nearby Snitterfield, a Fellow of the Royal Society, then by Mark Philips (1800–73), a Manchester cotton magnate and, in 1832, one of the city's first MPs – he was much involved in reform and education, and retired to Snitterfield in 1845, having bought the estate in 1816. By 1866 he had demolished the old hall at Welcombe and by 1869 had built a new house in a neo-Jacobean style at a cost of more than £35,000. Believed to bring good luck, Welcombe is a 'Calendar House', meaning

An LMS postcard view of the Welcombe Hotel: 'The New LMS Hotel,' it says on the rear of the card, 'England's Finest Country Guest House.'

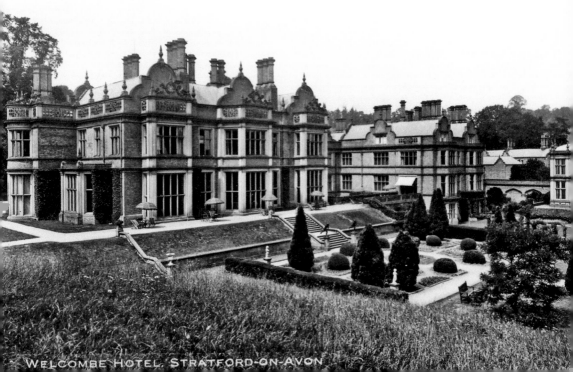

WELCOMBE HOTEL, STRATFORD-ON-AVON

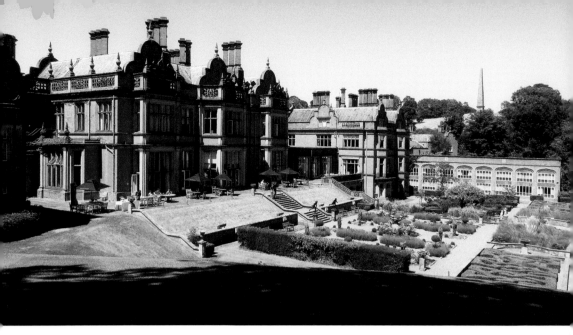

Nearly ninety years later, little has changed. The obelisk on the skyline is a memorial to Mark Philips.

that it has seven entrances, fifty-two chimneys, twelve fireplaces and 365 windows! After Philips's death it eventually passed by marriage to the Trevelyan family, and the eminent historian George Macaulay Trevelyan was born here in 1876.

The last Trevelyan died in 1928, and in 1930 Welcombe was bought by the London Midland & Scottish Railway (LMS) for £70,000; altered and extended, it was opened as a 131-room hotel in July 1931. Still a hotel, in the 1990s it became a spa and golf course, and is currently part of the Hallmark Hotels group.

The hotel has a unique connection with local railways (qv). As noted earlier, the Stratford-upon-Avon & Midland Junction Railway was very much the poor relation of the Great Western as far as railway provision in Stratford was concerned, so its successor, the LMS, decided to compete with its GWR rival by not only opening the hotel but linking it to the Old Town station by the 'Ro-Railer'. Introduced on 23 April 1932, Shakespeare's birthday, this was seemingly an ordinary Karrier road coach, but it also incorporated a set of railway wheels. The pneumatic road wheels and flanged rail wheels were so mounted that, when the vehicle arrived at Stratford from Blisworth, on the LMS main line, it was driven into the railway yard and the rail wheels could be switched to tyred wheels in less than five minutes by one man. The coach was then driven through the town to the Welcombe. The Craven-built body had twenty-six seats and luggage space on the roof. However, the experiment was discontinued after a few months due to vibrations, mechanical problems (a broken axle at Byfield) and a lack of passengers.

X

Xmas All Year Round!

'I wish it could be Christmas every day,' sang Roy Wood with Wizzard in 1973. Well, opposite Shakespeare's birthplace in Henley Street his wish has come true. The Nutcracker Christmas Shop is a branch of a family-owned business that was founded in 2001 in Crieff, Scotland. The Nutcracker Christmas Village in Crieff is the UK's largest, permanent, dedicated Christmas shop, with eleven 'houses' built around the village square, each containing its own special Christmas gifts. Santa has a room all to himself, and there's even a Christmas Cracker room.

All year round the Stratford shop is packed full of Christmas gifts and novelties, from genuine German wooden nutcrackers to nativity stables, Santas to stockings, tree decorations to reindeer – not the place for anyone who has a 'Bah humbug' attitude to the festive season!

Stockings, Santas and snow in profusion: the interior of the Nutcracker Christmas shop!

Y

F. R. S. Yorke

Francis Reginald Stevens Yorke was born in Stratford-upon-Avon in 1906, and dubbed the great 'apostle of modernism' in architecture in the UK. He trained at the Birmingham School of Architecture, and was one of the first British architects to design in a modernist style. He got to know many European architects while

F. R. S. Yorke's Mayflower Green cottages, set at right-angles to the Birmingham Road, have stone gable ends and a shallow pitch roof, surprisingly modern features for a building of 1938–39.

contributing to the *Architects Journal* in the 1930s, and in 1934 wrote the seminal work *The Modern House*, which demonstrated a detailed knowledge of European architecture and provided an introduction to modern architecture for generations of architects; he also helped lay the basis for the post-war fascination with concrete. In 1937, together with architect Frederick Gibberd, he published *The Modern Flat*, and in 1939 *A Key to Modern Architecture* with Colin Penn.

However, it was only after the Second World War, with new social and political changes, that he had commercial success as an architect, when what had been a small-scale avant-garde movement was transformed into the official, state-funded architectural idiom of the post-war welfare state. In partnership with Rosenberg and Mardall (YRM) from 1944 he helped to transform Britain's urban landscape with new housing, schools and universities; he died in 1962. The firm was responsible for the buildings at Gatwick Airport; floated on the stock market in 1987 as YRM plc, it was sold in 2011.

Francis's father, Francis W. B. Yorke (1879–57), was also a respected local architect. He was involved in the restoration of several buildings in the town, including the Town Hall after the 1946 fire, and the extension of the Shrieve's House in 1947. Father and son worked together on the restoration and extension of the Girls' Grammar School in Shottery Road for Fordham Flower in 1939. They were also responsible for the row of cottages at Mayflower Green on Birmingham Road, built in 1938–39 for the employees of Flowers Brewery. The seven brick-built cottages have shallow sloping roofs in the Scandinavian style, a relatively early use of this type of building that became very prevalent in early post-war housing schemes.

Z

'Zed! Thou unnecessary letter!'

In Act 2 Scene 2 of *King Lear*, the king's faithful friend and supporter Kent clashes with Oswald, the obsequious steward of Lear's alienated daughter Goneril. Kent, angry at Oswald for insulting Lear, tries to pick a fight with him.

During their furious exchange of insults, Kent calls Oswald, 'A knave, a rascal ... a base, proud, shallow, beggarly ... brazen-faced varlet... Thou whoreson zed! Thou unnecessary letter!'

So, since Shakespeare considers Z an 'unnecessary letter', this seems a suitably whimsical point at which to conclude our alphabetical excursion around Stratford upon-Avon!

Acknowledgements

I would like to thank the owners or staff of the following properties, who allowed me access to take photographs: Alveston Manor Hotel, Holy Trinity Church, Victoria Spa Lodge at Bishopton, the Nutcracker Christmas Shop, and the Welcombe Hotel. Thanks also to Chris Aston of Omnicolour for the photograph of the Stratford Blue bus, Ted McAvoy of Leander Architectural for permission to use the Royal Label Factory archive pictures, and the members of the fascinating and lively Stratford-upon-Avon Then and Now Facebook group.

Many books and websites, especially those of the properties and bodies concerned, have been consulted during the research for this book. Too many to mention individually, those that proved the most consistently helpful were British History Online (www british-history.ac.uk); historicengland.org.uk and www.britishlistedbuildings. co.uk, for entries on the various listed buildings; Grace's Guide to British Industrial History (www.gracesguide.co.uk); the Royal Shakespeare Company (www.rsc.org. uk); the Shakespeare Birthplace Trust (www.shakespeare.org.uk); and Sylvia Morris's very readable 'The Shakespeare blog' (www.theshakespeareblog.com). I have tried to corroborate as much information as possible across more than one source, but must take responsibility for any errors, omissions or misinterpretations.

About the Author

Although born in London, Will was brought up in Coventry, living there until he left to read English at Cambridge. There he was a member of the well-known Footlights Club, but failing to subsequently pursue a successful career as a scriptwriter and comedy actor he moved into publishing via ladies' knitwear and crossword puzzles (long story). He was Senior Editor with transport publisher Patrick Stephens Limited (PSL), part of Thorsons, until going freelance in 1990.

Today he divides his time between professional puzzle compiling and freelance book editing, working mostly for nostalgia publisher Silver Link Publishing in Northamptonshire. Also, twenty years ago he returned to his earlier love of comedy by co-writing and appearing in annual plays, revues and pantomimes for the local drama group, as well as being one half of comic song duo 'Sweet F.A.'.

He is the author of *50 Gems of Northamptonshire* (Amberley, 2017), and has also written several railway books, as well as some puzzle books.

He is married to Tricia, a professional librarian, and has two daughters, one a singer, the other a film producer.